STORYTELLING
WEDDING
PHOTOGRAPHY

Techniques and Images in Black & White

Barbara Box

AMHERST MEDIA, INC. ■ BUFFALO, NY

Dedication

I would like to thank my parents, for without them, nothing in my life would exist. I also need to thank my special niece, Meaghan McCafferty, for helping me get started on this project, and for helping me with my early editing.

A special thanks to my husband, Doug, for without our marriage, photography would never have been my career. Without his urging, I would never even have thought about writing a book. Without his love and encouragement, I would never have gotten up in front of an audience to share my thoughts and ideas on Storytelling Photography.

Copyright ©2000 by Barbara Box.
All photographs by Barbara Box and Douglas Box.
All rights reserved.

Published by:
Amherst Media, Inc.
P.O. Box 586
Buffalo, N.Y. 14226
Fax: 716-874-4508

Publisher: Craig Alesse
Senior Editor/Project Manager: Michelle Perkins
Assistant Editor: Matthew A. Kreib
Scanning Technician: John Gryta

ISBN: 0-936262-93-1
Library of Congress Card Catalog Number: 98-74595

Printed in the United States of America.
10 9 8 7 6 5 4 3 2 1

Table of Contents

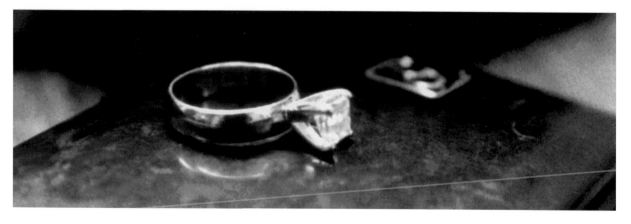

Introduction

Thank you for investing in this book. In it, you will learn my interpretation of wedding photography. Some of you reading this may have many years of experience on me, but this book is less about technique, and more about vision. It is about seeing wedding photography in a new and different light.

When I first arrive at a wedding and begin photographing, I try to put myself in the bride's state of mind. I ask myself certain questions from her perspective. What does she think is important? What will she want to remember? How can I tell a story of her wedding that will capture the day the way she always dreamed it would be? By getting into that state of mind, I get "into the zone," and put myself in a state of mind that allows me to be creative and see like a bride. After all, she is the one who must be pleased with the final product.

This book is the result of trying to "see like a bride" and capture the special moments and details which often go unnoticed in the larger picture of the day. These little things reveal the story behind the story and paint a picture of the wedding as the bride dreamed of

it for years, and experienced it on that day.

In the first part of the book, I will discuss the techniques I use to capture these genuine moments and details. In the second section, I will demonstrate how these images can be combined with traditional photography of the wedding (posed photography of the couple,

"...THESE IMAGES CAN BE COMBINED WITH TRADITIONAL PHOTOGRAPHY OF THE WEDDING..."

their family and wedding party), to create a fuller picture of the wedding day than most albums.

It is a style of photography that demands quick thinking and an unflinching knowledge of one's equipment, but one which also offers exciting possibilities to wedding photographers and their clients.

4

This type of image defines my style: a moment, a snippet of the whole story, and yet a story in itself. It was a fleeting moment in this young man's life as he attended his aunt's wedding.

The fine young fellow was about to walk down the aisle with his mom, who was a bridesmaid. I squatted down to shoot from a more interesting angle. Detecting motion, the boy turned his head, and delicately touched his fingers to his face. With a click, I captured this special moment. I couldn't have posed it; the image was just a fleeting moment that I had to be present and ready to capture.

In addition to the indicative unposed aspect of this image, this portrait also reveals the importance of modern photographic technology to this style. Auto-focus, matrix metering, fast film and fast lenses all allow me the freedom to work quickly and efficiently – all crucial aspects for successful storytelling photography.

"A MOMENT, A SNIPPET OF THE WHOLE STORY, AND YET A STORY IN ITSELF."

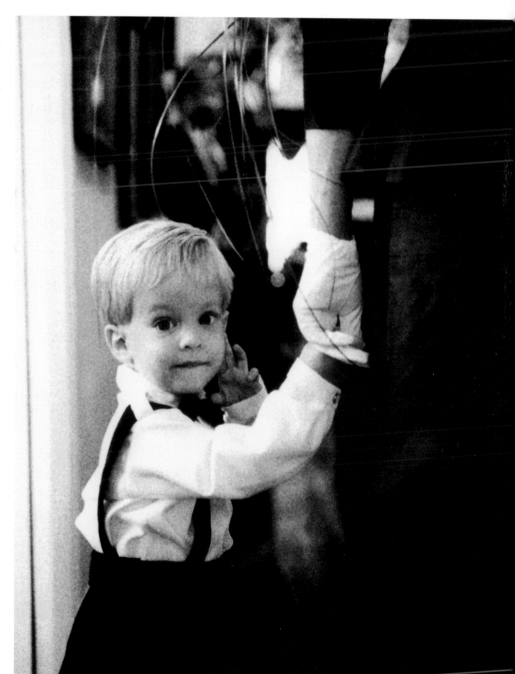

Getting Started

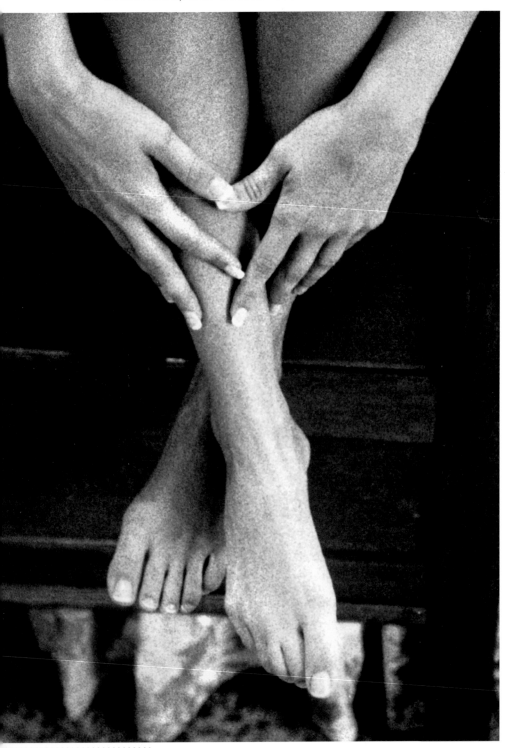

Photography tells two stories: the story of the subject who is photographed and the story of the photographer. This second story is often overlooked, but should not be so easily dismissed. Just as the choices we make in our lives are clearly influenced by our personality, history, education, etc., so too are these influences reflected in the subjects we choose to photograph and how we execute a portrait of that subject.

For instance, as a woman and a former bride, I am quite aware of all the fine tuning that goes into choosing the little details like the perfect stockings, the right undergarments to make the dress hang perfectly, etc. The importance of these details might never occur to someone who had never experienced them. On the other hand, another person might also see something different than I do, or choose to capture it in a different way than I do.

Our visions are unique and personal. To help you understand how I approach these subjects, I have provided a little background on the influences that have helped define my style.

As you may have read in the dedication of this book, photography was not a career I pursued from the start of my life. Still, I knew an artistic career was in my future. I loved to draw and Friday afternoons at St. Mary's Elementary School in Dedham, Mass., were my favorite, because it was time to do art!

As my education progressed, I still felt most comfortable in my art classes. I continued to college and studied at the Boston Architectural

Center for three years. While the bills were paid, it was wonderful, but eventually I realized I had to take inventory, and start working again, full time. I was devastated when I was forced to quit school, because I really felt that architecture was where I belonged.

But, as one door closes, another opens. After many years of working on my life, and enjoying architecture as a hobby instead of a career, I met a wonderful man, now my husband, Douglas Box. He is a Master Photographer, Kodak Mentor, speaker in the photographic industry and the Executive Director of the Texas Professional Photographers' Association. As you can well imagine, our relationship required me to live a crash course in photography.

After we married in 1996, I started working in the studio, designing wedding albums, and doing just about any other job he did not want or have time to do. I also assisted in weddings – running for lenses, changing film and fluffing dresses. I didn't complain about this aspect of the work, because it was how we made our living. But I did complain about attending receptions.

Most of the tasks I did for Doug were accomplished at the church, so there was not much in the way of work for me to do at the receptions. One Saturday, I informed my husband that I would be taking my own car to the reception. "Why?" he asked. I replied that if I had to listen to the Macarena one more time I would put a bullet through my head!

"What if I give you a camera? Then would you stay?" Doug asked. I replied with hesitation that I wasn't really a "touchy-feely" person, and I didn't like posing people or getting in their faces. I'm much more of a "behind the scenes" person. With that comment, an idea was born – and idea which has evolved and grown into the work in this book.

"'WHAT IF I GIVE YOU A CAMERA? THEN WOULD YOU STAY?' DOUG ASKED."

Details in Black & White

In the past several years, black & white photography has experienced a Renaissance. Television, advertising, the media, magazines and photography have all started to adopt a black & white style (or at least to rediscover it). This classic look is perfect for capturing the types of moments I am interested in presenting. Black & white's associations with fine art add a polished flair, and allow the viewer to focus purely on the subject rather than the color of the flowers or dresses, etc.

When I shot photographs at that first reception, Doug encouraged me to shoot what I saw – and what interests me is very different from what interests him. My own experience as a bride had changed the way I looked at a wedding.

As a result of our upbringing and interests, I think women are more intuitively connected to the priorities of the bride than are male photographers. We have a stronger appreciation for how the bride has agonized over her choice of shoes to find the ones that are a perfect match. We know how she has carefully selected her hosiery and undergarments so that her dress will flow beautifully as she walks down the aisle.

Once the introductions are over at the start of the wedding, I simply let myself fade into the background, and begin shooting these carefully chosen, yet often overlooked elements which I know the bride will want to remember.

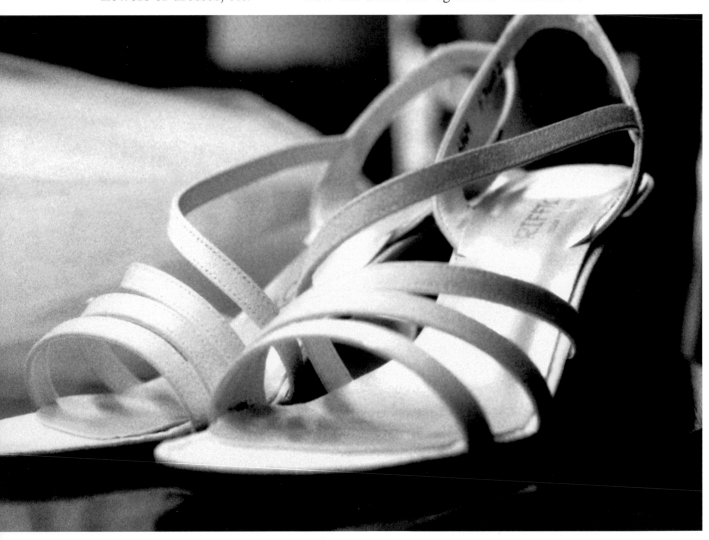

Accessories help to define each wedding. Although each bride's accessories may appear similar, to each woman they are intensely personal items she will have chosen carefully. I like to find interesting groupings of rings, invitations, gloves, pillows, shoes, jewelry, ties, etc. and shoot them together.

Each item has a story, and I don't redesign the scenes I find (for these scenes have their stories too). I simply photograph what I find, not what I can arrange.

"I LET MYSELF FADE INTO THE BACKGROUND, SHOOTING THESE CAREFULLY CHOSEN, YET OFTEN OVERLOOKED ELEMENTS..."

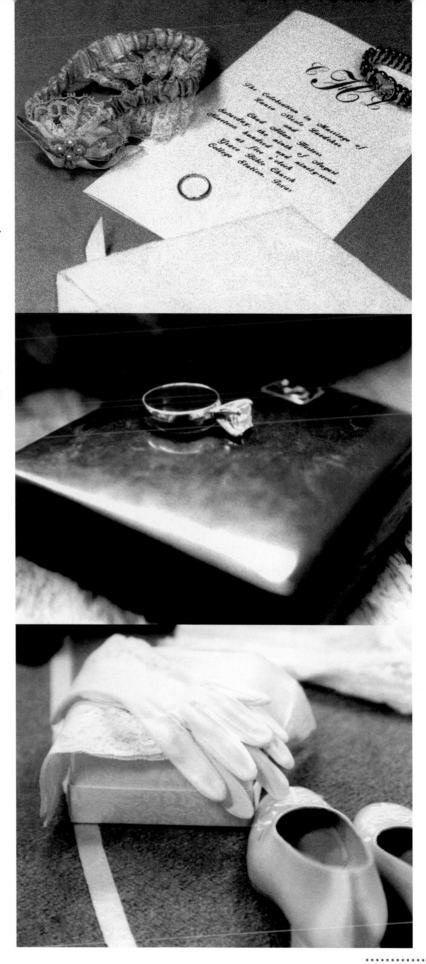

Telling A Story

You don't need to tell the whole story in one photograph. Telling only part of the story will eliminate the confusion that can occur when you try to get too much into a single frame. When you have an involved message to communicate, consider shooting a series of images.

The accessory in this series of images is a string of pearls that was a gift to the bride from her groom at the rehearsal dinner the night before. They are the focal point of each image.

For the top image on this page, I tilted the camera to add a little interest to an otherwise rather static pose. The tilt here forces the viewer's eye to start at the bottom of the image and move directly to the pearls. Her hands stop your eye, and holds your attention on the intended focal point of the image – the string of pearls.

The second image (at the bottom of this page) completes a simple, but emotional story, as the mother's hands reach to help her daughter with the necklace. I simply waited until the bride looked down at the necklace and raised her hands – delicately touching and almost caressing the gift from her groom. Henry Cartier Bresoun called this the "decisive moment."

"WHEN YOU HAVE AN INVOLVED MESSAGE TO COMMUNICATE, CONSIDER SHOOTING A SERIES OF IMAGES."

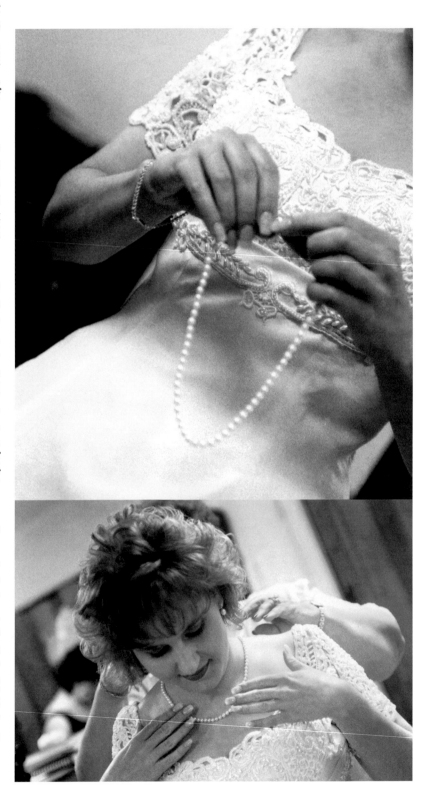

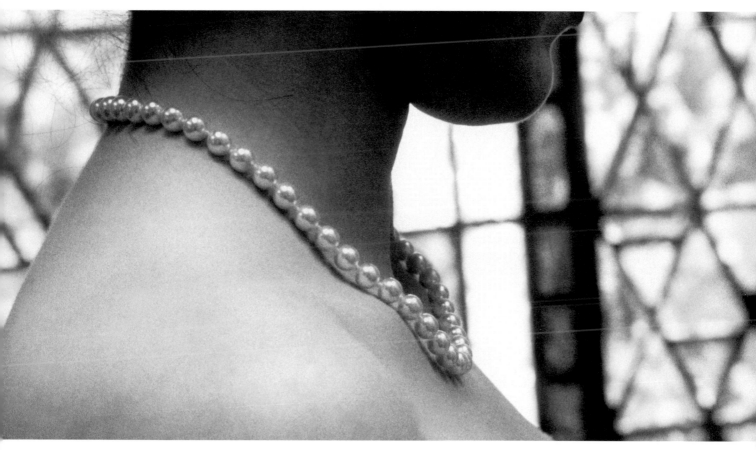

Action happens very quickly when the bride is dressing, so you must be prepared to work and shoot at any given moment. I generally carry a couple of rolls of un-wrapped film so that I am always ready.

Next to the dress and veil, the bride's shoes are the most important part of her wedding day attire. Even though hardly anyone sees them, be sure to capture them on film. A great time to get an image of the shoes is when the father is placing the garter.

I can't imagine where the tradition of the garter originates (probably in the days before panty hose). I'm not fond of the garter tradition, since it has become a rather raunchy element of the wedding, but I do shoot it – usually a very tasteful close-up.

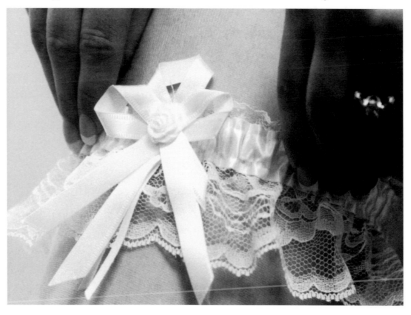

One last (and often touchy) area is photography of the bride's undergarments. Some brides are more free than others with their bodies and what they will allow

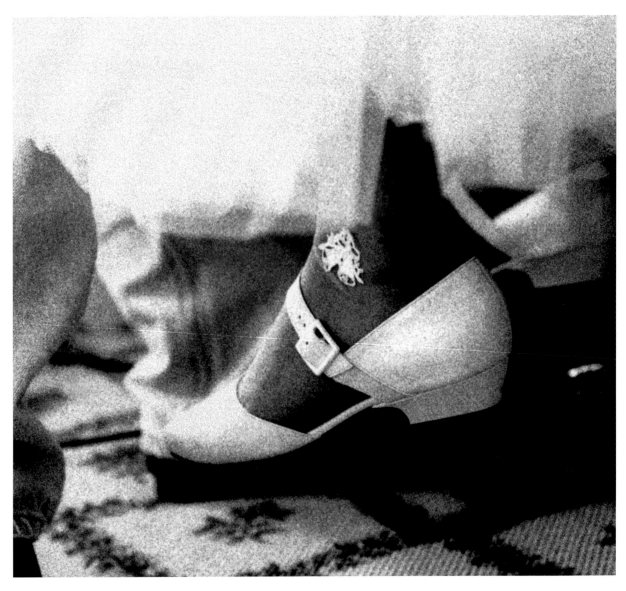

you to photograph. Watch the bride carefully and observe her body language to determine her comfort level. Before you begin, talk to her and assure her that you would never shoot anything embarrassing or inappropriate. If a bride is particularly flamboyant, I have gone so far as to make a small private album for the groom – but always ask the couple's permission first!

The finishing touch is her mother's or grandmother's handkerchief. It is a totally sentimental tradition, handed down generation to generation, but that's what weddings are all about. Some brides tie the handkerchief around the base of their bouquet, so keep your eyes open.

I made the image above while the bride was having her hair and make-up done. Had I not been taking the time to discover what made this bride special, I might never have noticed her special hosiery.

"ASSURE HER THAT YOU WOULD NEVER SHOOT ANYTHING EMBARRASSING OR INAPPROPRIATE."

Over the past two years, the phrase "Life imitates art" has certainly become true for me. As the youngest of four, I am the product of a babyboomer family. My parents were married at the age of thirty in 1946, just after World War II. Consequently, as I grew up, my parents and our relatives were elderly. As a teenager, I spent more time in nursing and funeral homes than most people of my age.

A beautiful reflection of my time spent with the elderly has emerged in my photography, as I have gravitated toward photographing them. They were a very important part of my past, and continue to be an important part of my photography today.

"AS I GREW UP, MY PARENTS AND OUR RELATIVES WERE ELDERLY."

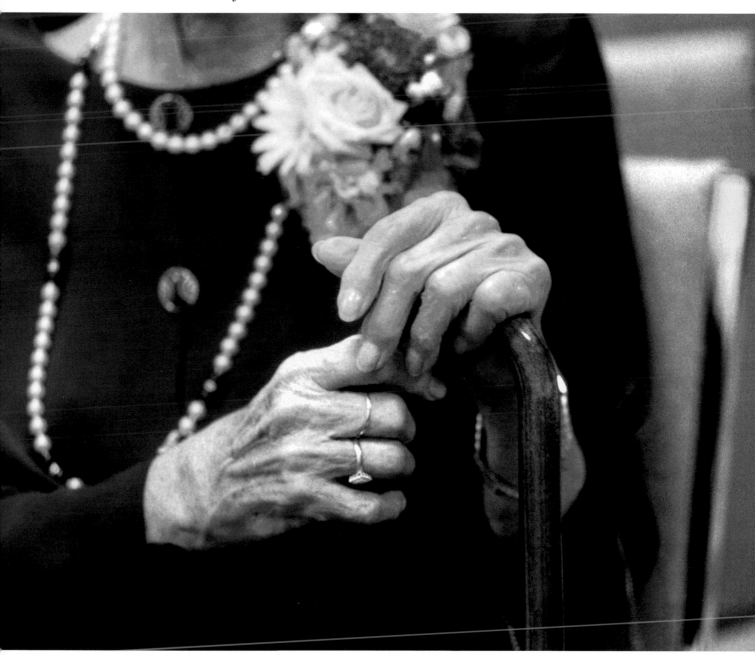

The elderly man in the photograph on the left is the the bride's grandfather. The woman behind him, steadying him, is his daughter. I went to find him so that Doug could do a formal portrait of him. We always make a point of photographing the grandparents alone. He was hesitant about coming with me, due to his unsteadiness, but I convinced him. While Doug was setting him up for the formal portrait, I was able to capture two interesting images of the bride's grandfather.

"WHILE DOUG WAS SETTING HIM UP FOR THE FORMAL PORTRAIT, I WAS ABLE TO CAPTURE TWO INTERESTING IMAGES OF THE BRIDE'S GRANDFATHER."

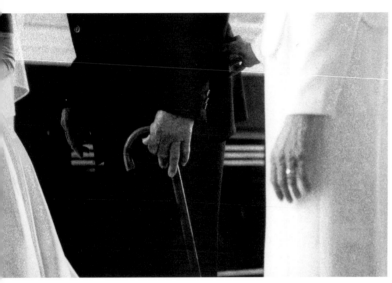

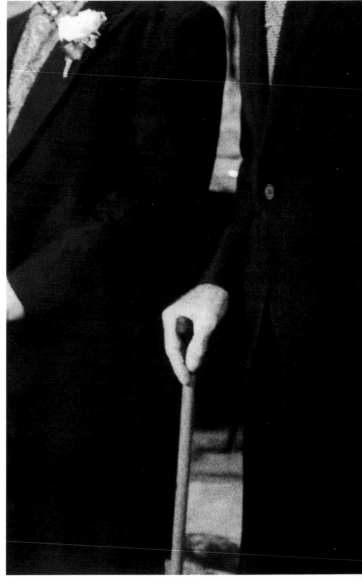

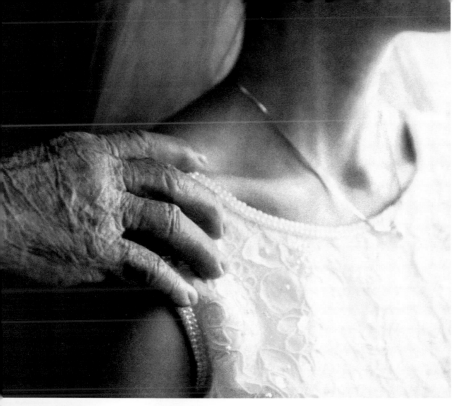

I love the character of elderly people – although sometimes they are reluctant to be photographed. Some think they are too old, not pretty enough, or much too wrinkled.

My favorite thing to photograph is their hands, for these truly reflect the story of their lives. I study how they cross their hands on their laps, how they hold their canes, and how the jewelry that used to fit so well now seems to twist loosely on their fingers.

I always include these images in the bride's album, because if you have held these hands, you do not need to see the face to know to whom they belong.

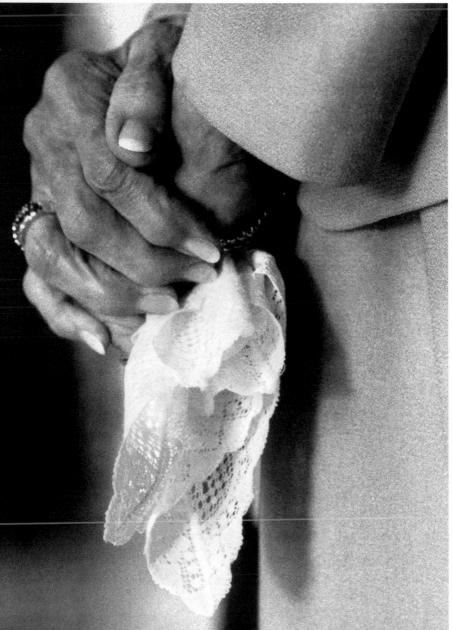

"I STUDY HOW THEY CROSS THEIR HANDS ON THEIR LAPS..."

Religious Art

Growing up Roman Catholic meant spending lots of time in church. The parish in which I was raised had a beautiful High Gothic cathedral.

I spent many Sunday mornings, as a child, staring at the beautiful bas-relief renderings of the stations of the cross. I looked wide-eyed at rib vaulting and wondered how it the world it was built, and how it stayed up. There is something magical and symbolic about the art and architecture of a church.

It was here that I fell in love with sculpture, without even completely realizing it. Now, I can see how this past has become an important part of my art.

Because I am so attracted to this subject matter, I scan for the interesting elements in every church where we shoot a wedding. I try to put myself in the bride's place. After all, she selected this place as the site for one of the most important days of her life. I try to find the elements that made it special enough for her to choose it.

"... SHE SELECTED THIS PLACE AS THE SITE FOR ONE OF THE MOST IMPORTANT DAYS OF HER LIFE."

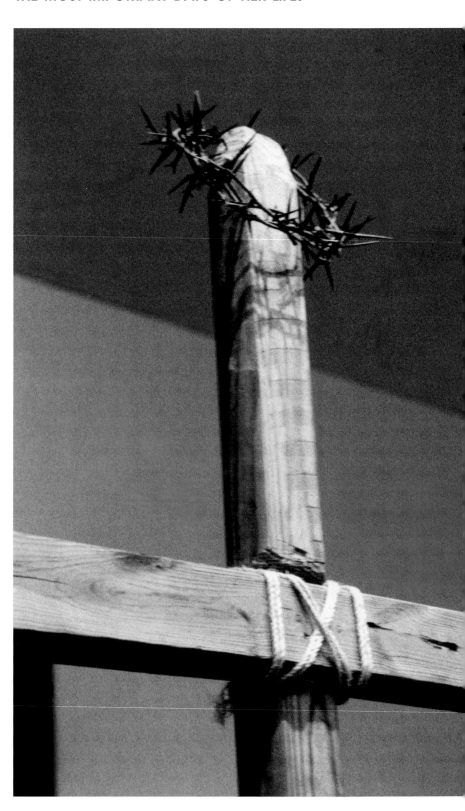

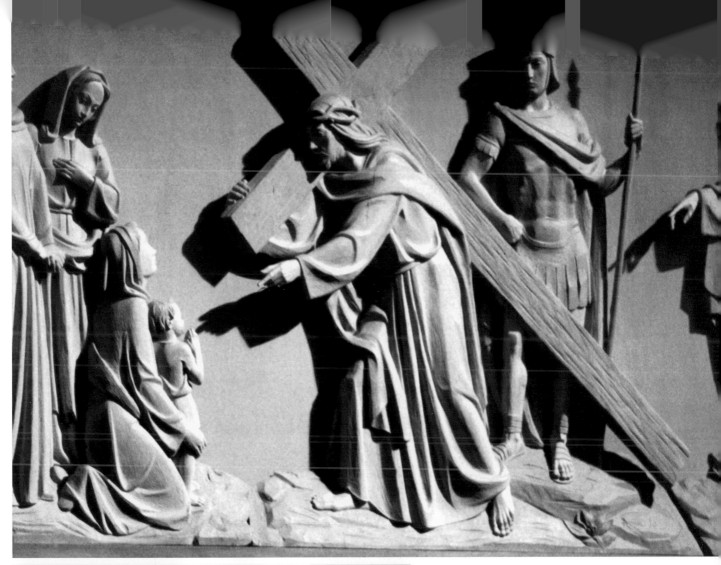

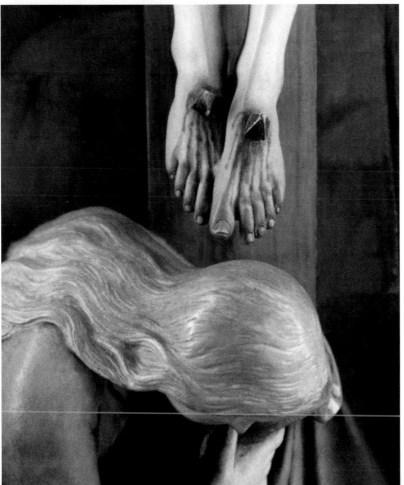

"THERE IS SOMETHING MAGICAL AND SYMBOLIC ABOUT THE ART AND ARCHITECTURE OF A CHURCH."

Bridal Dressing Room

One of the best things I have done in my career as a wedding photographer is to make sure I always arrive early at weddings. In my area, most of the brides get dressed at the church, so I make sure always to arrive there at least half an hour before the bride. Getting there well before the bride allows me to truly tell the story of the wedding from start to finish – depicting the day more completely than I could if I arrived later.

If I have never photographed at the particular location before, I make it a point to arrive even earlier. This allows me the luxury of a little time to absorb the details of the church. I love the challenge of working in churches, reception halls and country clubs that are new to me. Being forced to look for different angles, art and architectural elements and other nuances helps me to stretch my creativity.

"I MAKE SURE ALWAYS TO ARRIVE AT LEAST HALF AN HOUR BEFORE THE BRIDE."

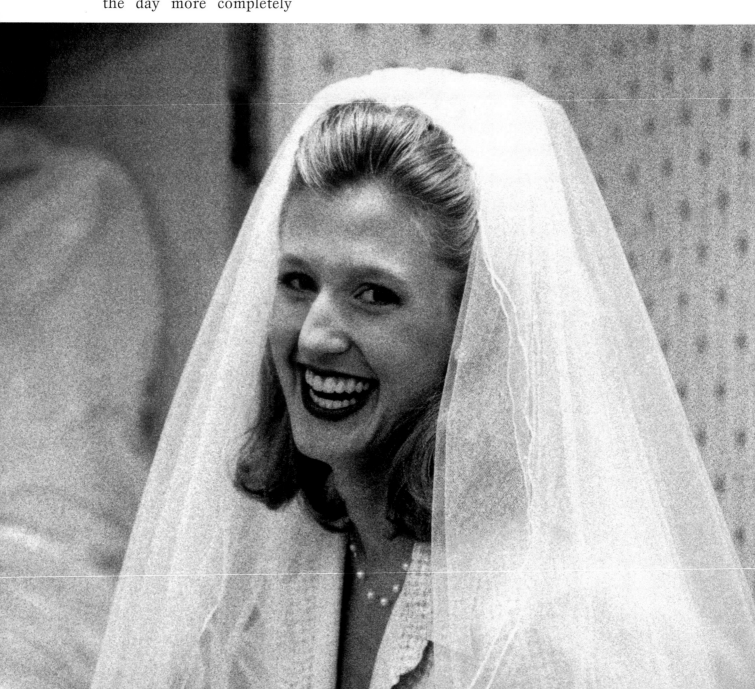

Once the bride and company arrive, I am there to observe each one of them and how they interact with each other. After the first few minutes, the bride and girls generally don't even notice me anymore. Once they begin to relax and act naturally, I make sure to fade into the background and stay there. It is when they forget I am watching that I can begin to capture the most interesting shots.

The "getting ready" part of the day is one of the most fun and interesting to photograph – after all, it's the beginning of a dream-day! You can feel the excitement and happiness like static electricity in the air after a lightning strike. Smiling, laughing, anticipation – a wide variety of emotions abound, waiting to be captured on film.

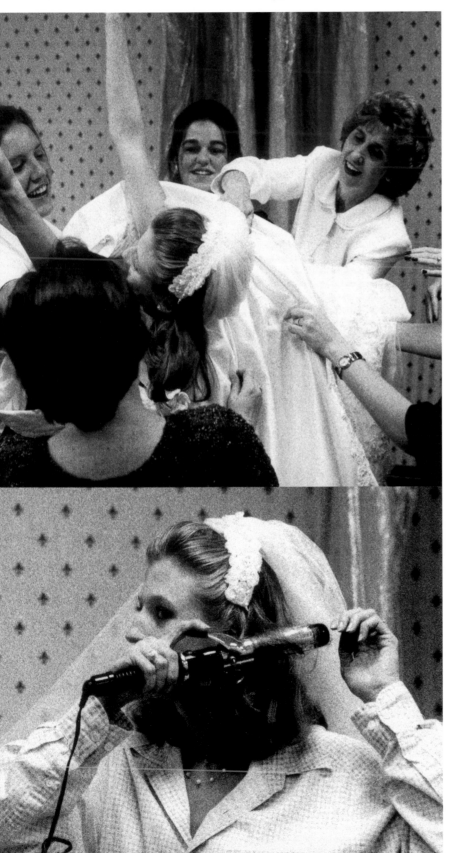

"YOU CAN FEEL THE EXCITEMENT AND HAPPINESS LIKE STATIC ELECTRICITY IN THE AIR..."

The dressing room ritual is a traditional rite of passage shared by the bride, her female friends, her sisters, mother, grandmothers and other female relatives. The married women share in the ceremony, remembering themselves as brides, while the unmarried women and girls join in, imagining the day they too will be brides.

The Nikon's fast auto-focus and matrix metering on the program setting in invaluable for capturing the action as everyone scurries to prepare for the ceremony. The action is fast and you have to stay on your toes and keep your eyes open to capture all of the important moments.

As you shoot, remember that a wedding doesn't just happen accidentally. It's not the result of a fleeting thought. The couple (and especially the bride) has spent hours, days, and weeks – even months – planning this one day. Every single moment and every little detail have been visual-ized and planned carefully. Things that might not seem terribly important at first glance, may be quite impor-tant to the bride. Watch her carefully, concentrate on the emotions you feel in the room and work to cap-ture these important little details she has worked so hard to plan.

"EVERY SINGLE MOMENT AND EVERY LITTLE DETAIL HAVE BEEN VISUALIZED AND PLANNED CAREFULLY."

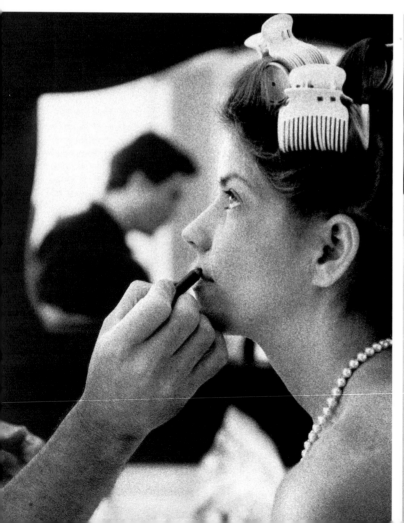

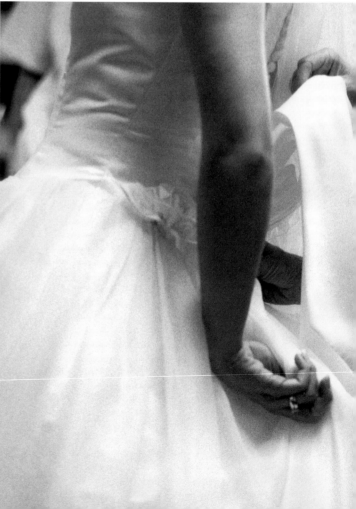

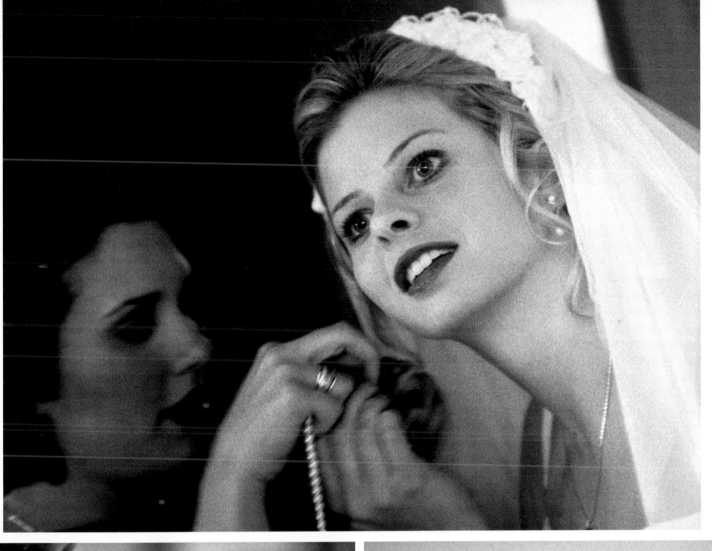

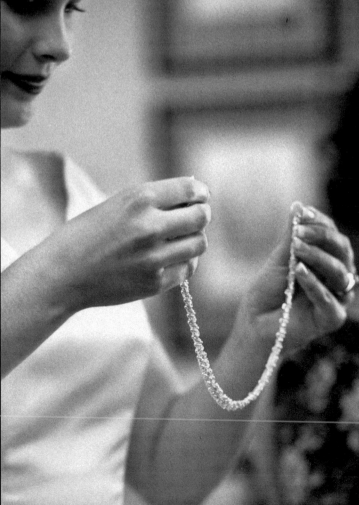

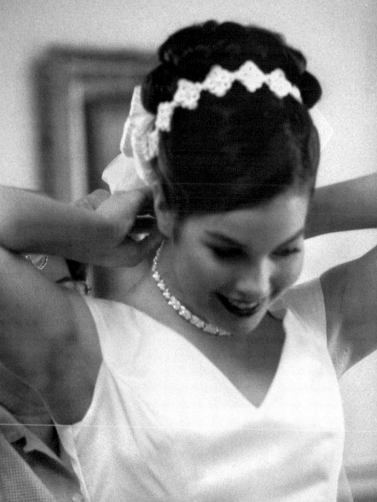

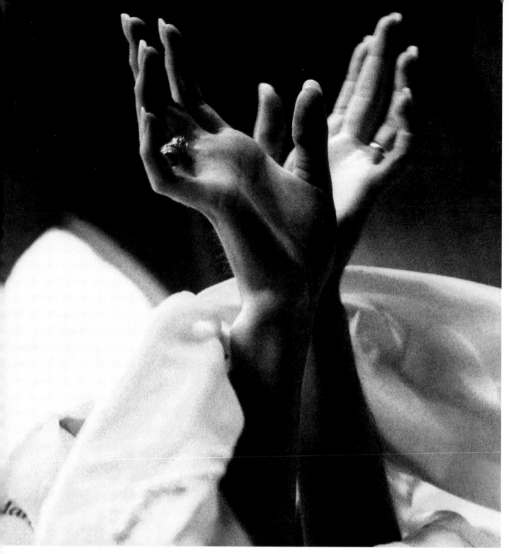

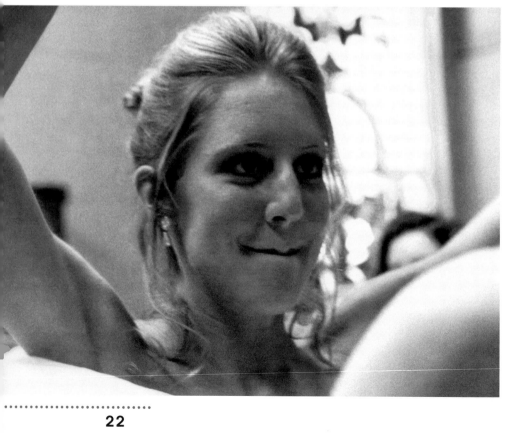

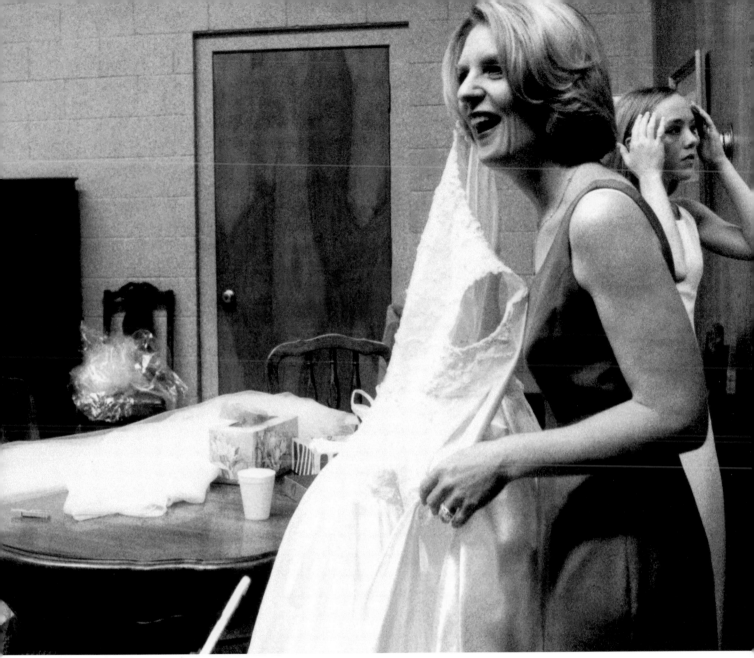

Beautiful and natural hands rise up elegantly as her attendants help slip the wedding dress over the bride's head (opposite page, top, left). To capture an image like this you need fast film, fast lenses, auto focus and matrix metering – simply because the moment is there and gone in less that a second. Fluorescent lights above and a small window to the left of the camera provided the illumination for this image.

As for the image at the lower left (opposite page), I'd have to guess most men wouldn't have a clue what this bride is doing. She's pressing her lips together to avoid soiling her gown with lipstick as it is pulled over her head. To successfully shoot this phase of the wedding, you must be on the lookout for defining moments like these which truly reflect the bride's experience of the day, not just the day that the guests see.

"BE ON THE LOOKOUT FOR DEFINING MOMENTS LIKE THESE WHICH TRULY REFLECT THE BRIDE'S EXPERIENCE..."

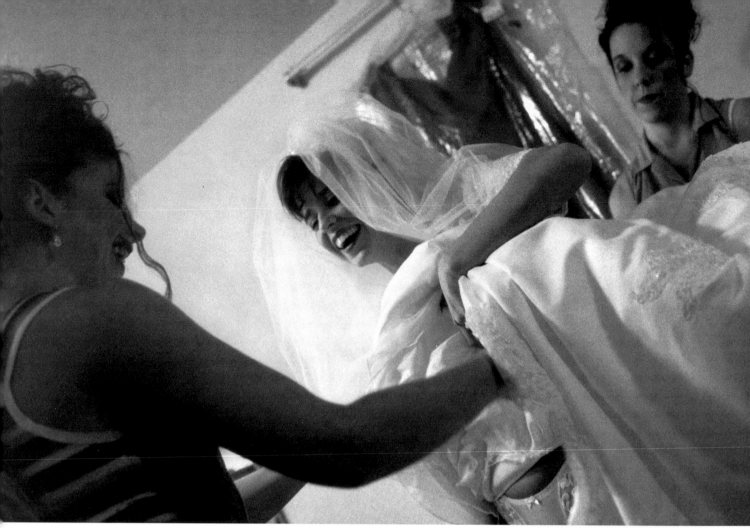

Shooting from a low camera
angle can add interest to
your composition. Tilting
the camera (as above) also
strengthens composition by
creating diagonal lines
which attract the viewer's
attention.

Chances to experiment and
seek out new images abound
during this phase of the
wedding. Look for opportu-
nities to capture a bride's
reflection in the mirror as
she puts on her make-up.
Consider shooting silhou-
ettes. All the shapes and tex-
tures, faces and emotions of
this quick-paced, varied
environment can provide
great subject matter for
powerful images.

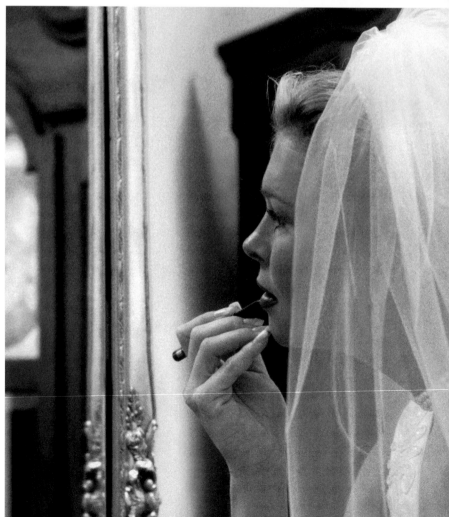

Every wedding dress is unique. From contemporary to classic, casual to formal, the bride has chosen her particular dress for reasons known only to her. Not only is it probably the most costly garment she'll ever own, the gown is also the ultimate expression of her personality on this day. Showy or plain, simple or elegant, her dress reveals more about the bride than any other element of the wedding day. I think the dress sets the mood for the entire day.

That said, the gown is also one of the most important elements of the day for you to document fully in your photography. Look for all the details which make it unique.

You should also look for ways to capture how the bride wore the dress. By this, I don't mean how she put it on, but how she carried herself in it. The image below is a perfect example of what I'm talking about. From the way the bride clasps her hands behind her back, you can see that this bride wears her gown as comfortably as a worn pair of blue jeans.

"THE BRIDE HAS CHOSEN HER PARTICULAR DRESS FOR REASONS KNOWN ONLY TO HER."

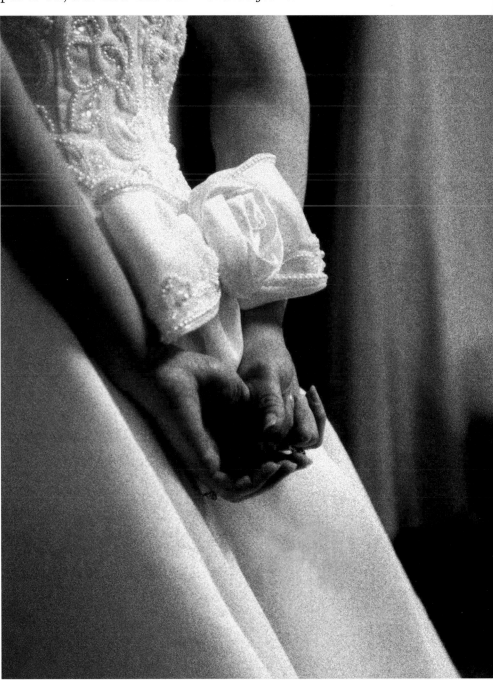

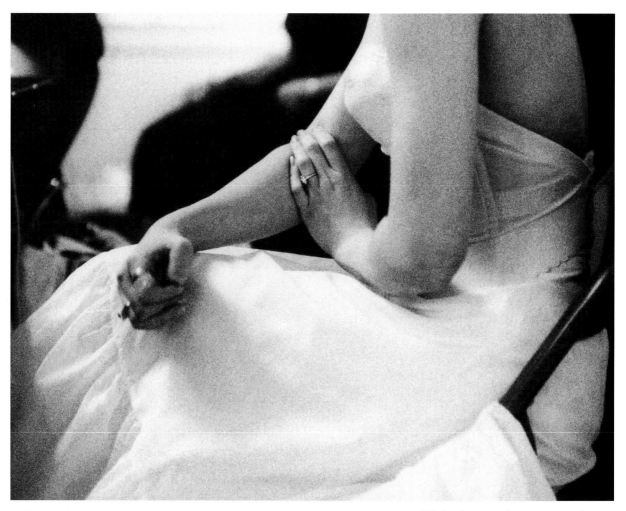

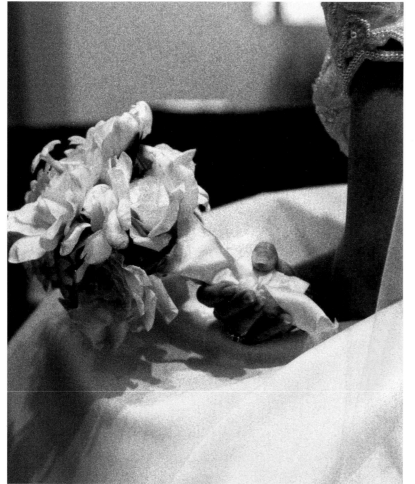

This is another example of documenting how the bride wore her dress. Above, we see the bride in her underclothing, seated casually in her dressing room. The second image shows the same bride in her gown during the formal portraits. With the exception of the bouquet, the pose is exactly the same in each image. I was successful in this example because I captured the bride acting naturally. This is just how she normally sits. This is exactly what I want to achieve in my images – a portrait that her friends and family will see and say "That's so you!"

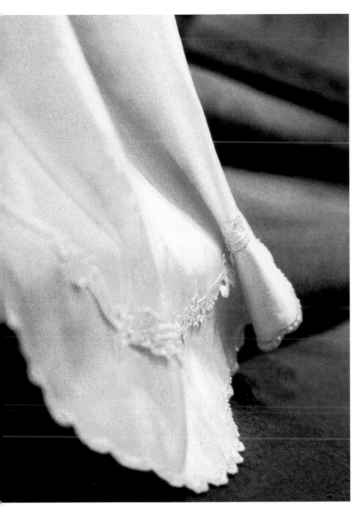
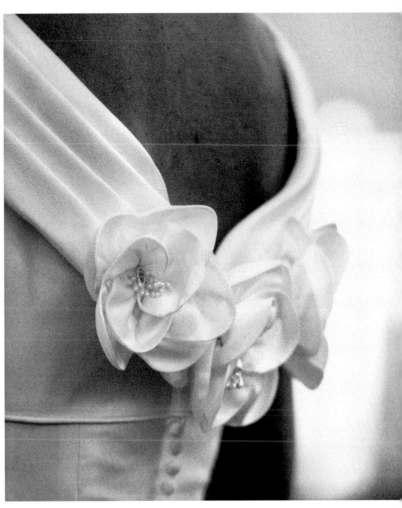

To the untrained eye, one wedding dress may look pretty much like every other wedding dress. To avoid missing what makes each bride's gown special, try viewing the dress in pieces as well as the whole. Buttons, bows, beads, sleeves, neckline, length, style, material, train, and bustle vary widely from gown to gown and help show the uniqueness of the dress. Show those differences and celebrate them.

While you'll get some pictures of the gown as you are shooting in the dressing room, you should look for opportunities throughout the day to shoot the bride in the dress she'll wear only once. During breaks from the formal portraits, as they couple is leaving the church, during the reception – look for light and poses that flatter and show off the unique features of the dress.

"LOOK FOR LIGHT THAT FLATTERS AND SHOWS OFF THE UNIQUE FEATURES OF THE DRESS."

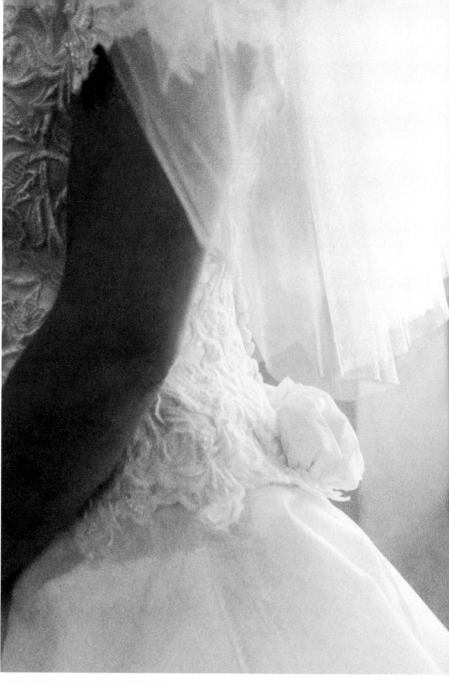

I'm always looking for unique angles and unique lighting situations.

In the top image, I photographed the glow of light coming though the veil from a window directly behind it. This light brings the veil to life with a radiant glow. It also outlines the shape of the bride, skimming across the dress and revealing the differing textures of the fabric on her bodice and skirt.

In the lower image, I used the light coming through an archway as the setting for a portrait of the bride. The tilt of the camera creates diagonal lines which contribute to the strong composition. Popular in beauty and fashion photography, this tilt also adds a contemporary look and sense of movement. The bride's graceful pose and the flow of her veil add to all of these aspects.

"THIS LIGHT BRINGS THE VEIL TO LIFE WITH A RADIANT GLOW."

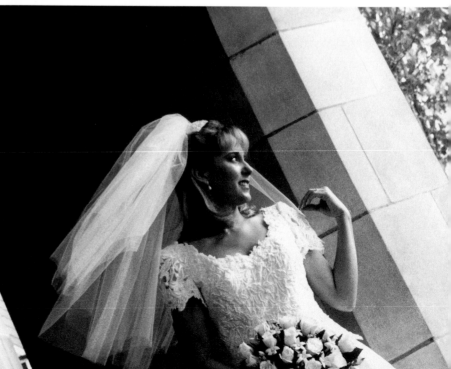

One of the most important aspects of this style of story-telling photography is its ability to capture the emotions of the day. Weddings offer a photographer the opportunity to capture a wide range of expressions and feelings.

The nervous faces of the bride and groom, the emotions of the parents seeing their children all grown up, the joy of friends and family surrounding the couple, or even the playfulness of children – all of these offer the potential for a truly memorable portrait. Above, a bride's laughing smile or, below, the bride delicately holding her grandmother's handkerchief, are examples of this style.

But you must never let your guard down for an instant. These moments happen in a flash and then are gone forever. It is crucial to invest in equipment that lets you work fast. Take the time to get to know that equipment inside out and backwards so you can make adjustments almost instantly, and almost without thinking.

Fast film will also be a great asset when shooting on the fly. This will accommodate hand-held shots (often of moving subjects) in a wide variety of lighting environments with short exposures to help ensure a crisp final print.

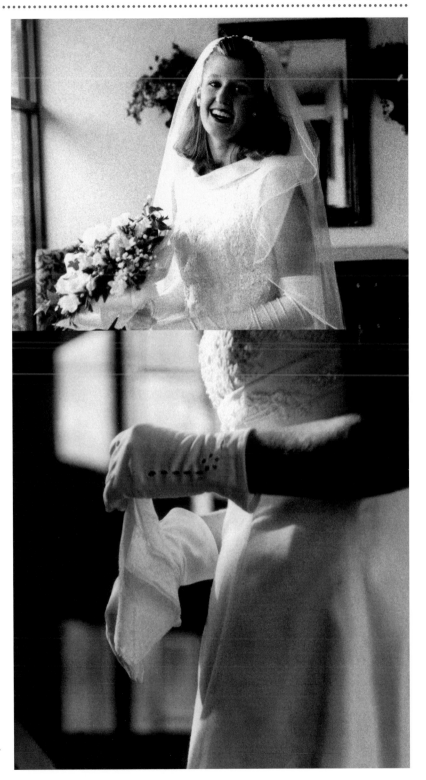

"THESE MOMENTS HAPPEN IN A FLASH AND THEN ARE GONE FOREVER."

The Veil

The veil is a wonderful accessory to the wedding gown ensemble. It it the bride's crown. Veils come in many lengths and styles and are selected according to the bride's taste. Therefore, like her dress, the veil she chooses is important to photograph.

My favorite type of veil to photograph is one with a blusher (a part of the veil which covers the bride's face as she walks down the aisle). I personally find it a very romantic look. Two beautiful shots to look for with a bride who has a blusher are when her father gives her away and kisses her good-bye, and when the groom gives her a hello kiss.

Whenever possible, I also try to shoot the veil alone. I watch the bride carefully. Most women nonchalantly carry the veil into the dressing room with them and hang it on a convenient mirror, doorway or chair. This gives me a great opportunity to get a shot of the veil by itself, precisely where the

"THIS GIVES ME A GREAT OPPORTUNITY TO GET A SHOT OF THE VEIL BY ITSELF..."

bride herself has placed it. Images like this trigger memories of the wedding day that might otherwise have been lost in the blur of activity. As this example indicates, when shooting at weddings, I try not to move anything, if possible. My goal is to capture the day as it happened, not to pose people or set up shots. That job falls to my husband, who handles the portrait photography for the event.

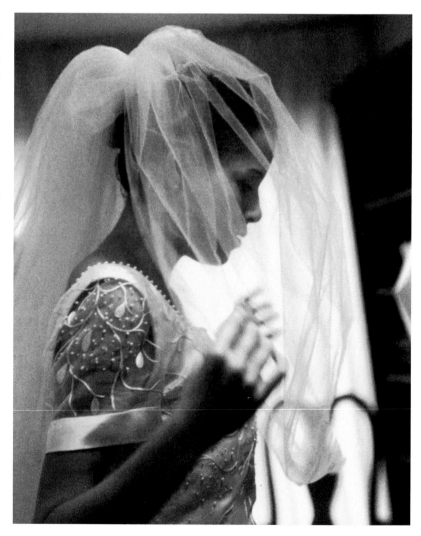

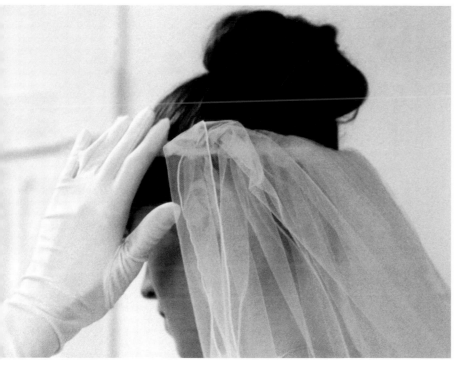

I'm constantly looking for opportunities to photograph little details like the texture and design on the veil (bottom left). I also seek out moments when people are just being themselves. In the image on the opposite page, I photographed the bride as she stepped away from her maids for a quiet moment. As I saw her moving away, I positioned myself for this charming profile that also shows of her veil. Profiling her face against the window adds a little extra drama. Portraits like this capture forever a little private moment that she might otherwise never have remembered. Another version of the same moment can be viewed at the bottom right of this page.

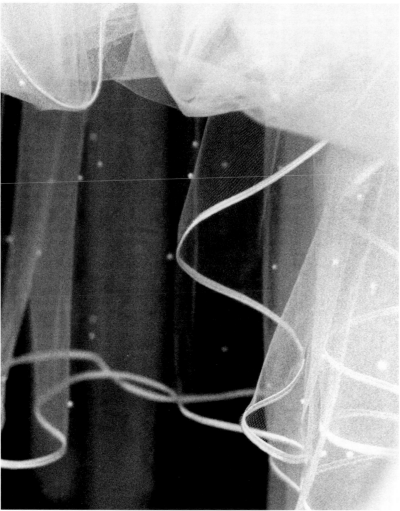

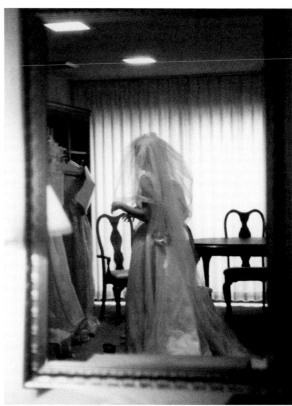

A Special Day

Even though you may, as a wedding photographer, attend a wedding every week, remember that your subjects do not. For them, and particularly for the bride, this is an extremely unique event of tremendous importance.

You need to be in tune with your subjects' excitement and never let it seem as though theirs is "just another Saturday." Brides want to feel as special as they are on this fairy-tale day. With careful attention to detail, you can help her feel that way.

Getting in tune with the emotions of the day will also help assure that, when she sees your images, the bride will be thrilled with all of the special moments and emotions you were able to capture.

The bride is your client. She selected you to be a part of a very special event in her life, and what's more, to be responsible for a very important facet of that event. She saw a unique quality in you that made her pick you from all the others, and you can return the favor by finding what is unique about her and her wedding, and lovingly rendering it on film.

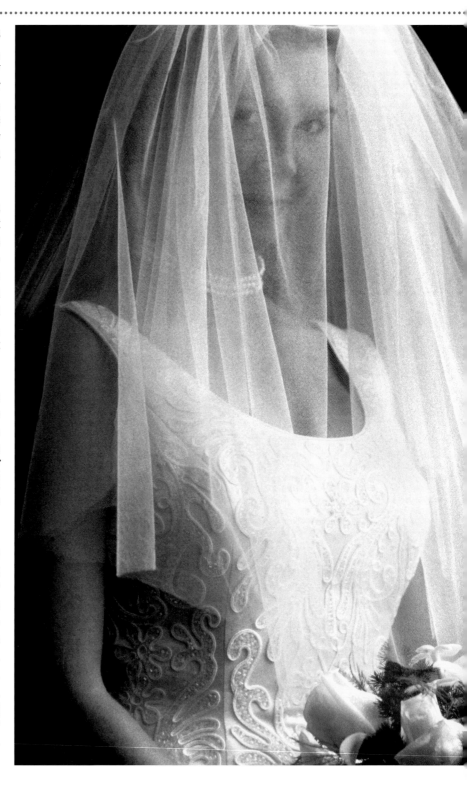

"FOR THEM, AND PARTICULARLY FOR THE BRIDE, THIS IS AN EXTREMELY UNIQUE EVENT OF TREMENDOUS IMPORTANCE."

I always enjoy watching and photographing children at weddings, and find it interesting that brides are willing to share the spotlight with these little stage-stealers! Usually, it's indicative of her strong relationship with the special children in her life.

In any event, children add a simple and special kind of magic to the day. Little girls seem especially to enjoy the experience, perhaps because they love the chance to dress up and dream of the day they too will be a bride – and princess for a day.

"...CHILDREN ADD A SIMPLE AND SPECIAL KIND OF MAGIC TO THE DAY."

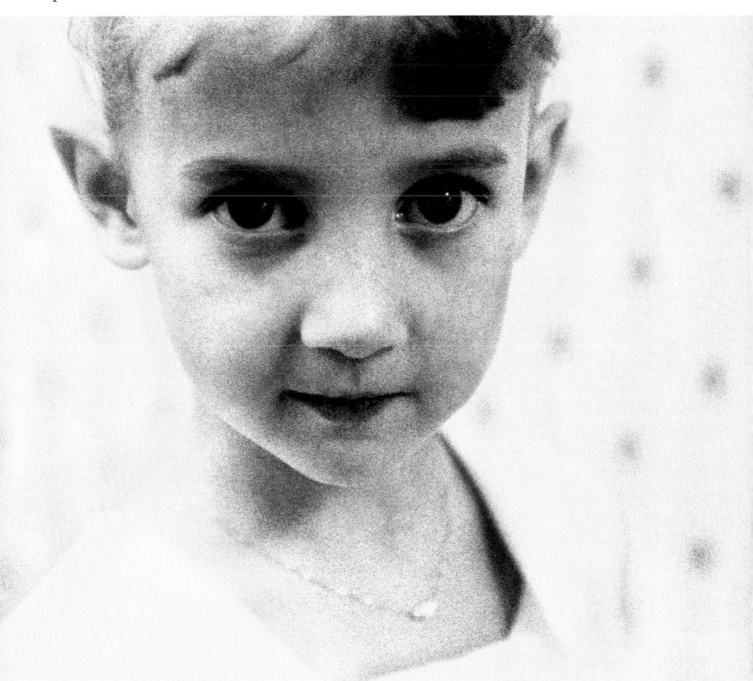

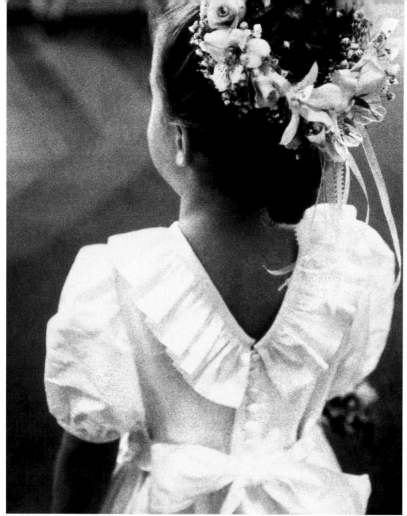

This little vignette illustrates how seriously some little girls take their duties as flower girls.

I shot these images while Doug was working on the formal portraits. This little flower girl was practicing straightening out the bride's train, as she would be responsible for doing later during the actual ceremony.

These images also illustrate how shooting a series can be used to effectively communicate a story too complex to be told in a single frame. By simply shooting as the action was unfolding, I created a memorable series of images to tell the story of a

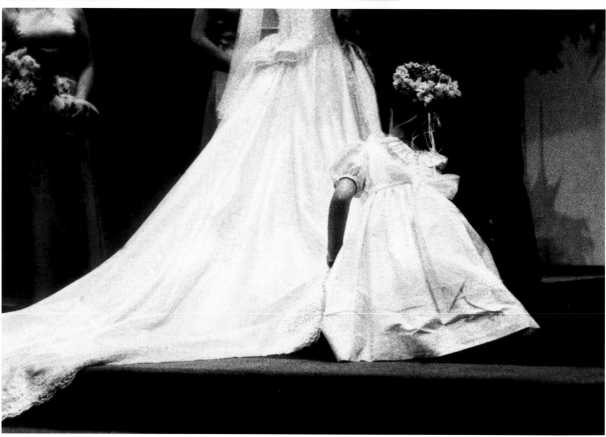

cute little interlude at the wedding. Again, the bride chooses to have children in the wedding because they are special to her – and she'll appreciate your efforts in depicting what makes them so special.

"I SHOT THESE IMAGES WHILE DOUG WAS WORKING ON THE FORMAL PORTRAITS."

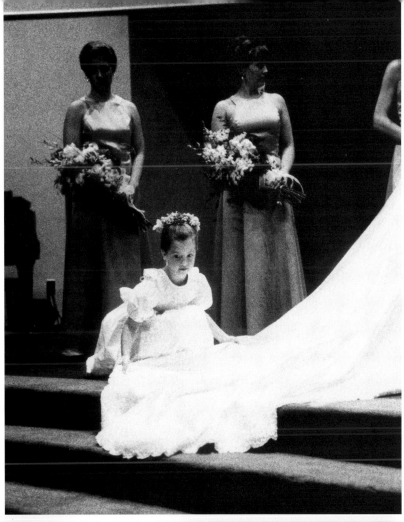

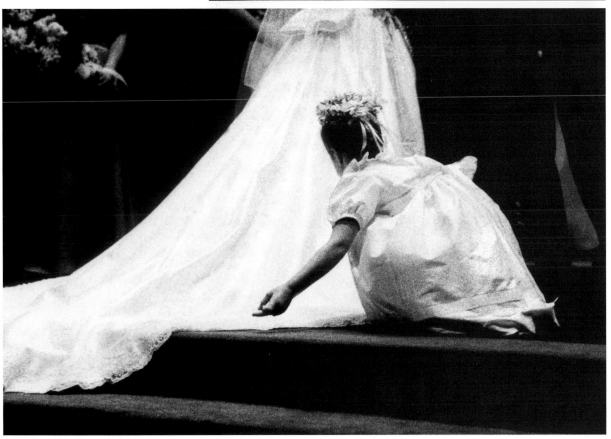

This wedding had four flowergirls – and each had a special relationship with the bride. The parents of the little girls went to great lengths and expense to make sure their daughters looked wonderful for the day.

Since the formal portraits, which Doug shoots in color, will show exactly how the dresses and flowers looked, I make a special effort to focus on capturing the personality of the girls.

Just as when I am shooting the bride and her maids in the dressing room before the ceremony, I watch carefully the interactions between my subjects. I watch their emotions. Are the girls nervous about their big role in the ceremony? Are they excited? Children wear their emotions closer to the surface than most adults, so time spent carefully photographing them can lead to some outstanding images.

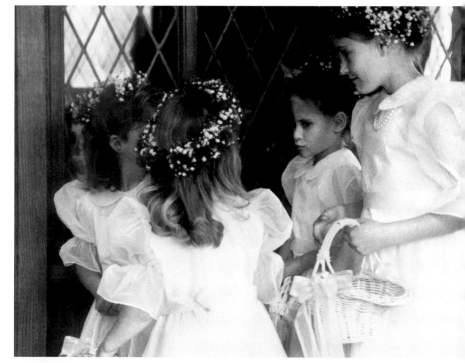

"I MAKE A SPECIAL EFFORT TO FOCUS ON CAPTURING THE PERSONALITY OF THE GIRLS."

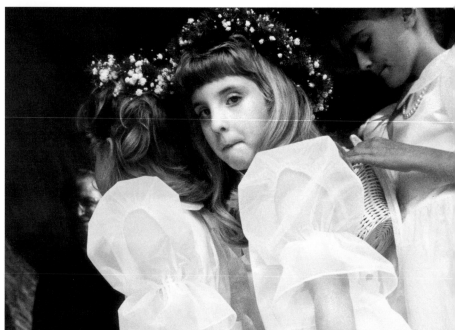

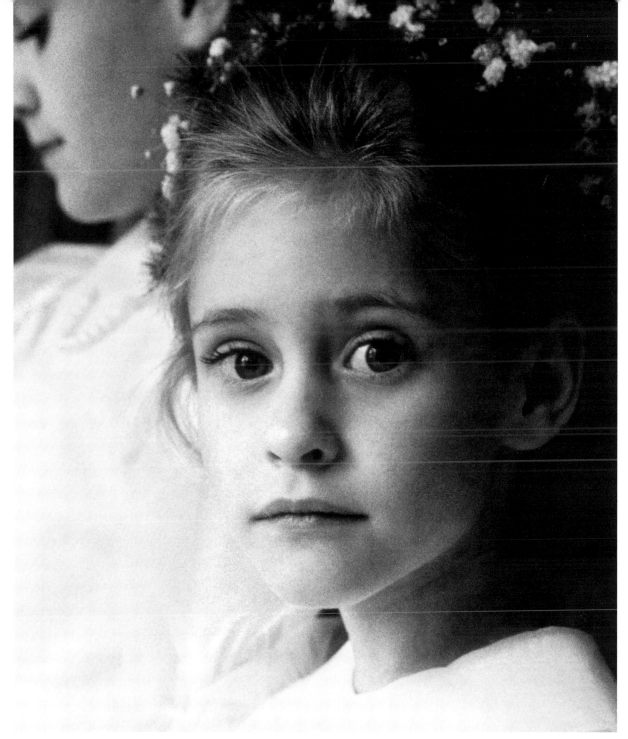

The preparation, the waiting, the anticipation, the fun – it all leads up to the big day, and the big performance for kids in the wedding. It also adds to the excitement of the day when it finally arrives.

One of the most important things to remember in this photojournalistic style of wedding photography is not to try to say everything in one photo. Show only what is necessary to tell the story. You don't even need to tell the whole story. Think of it as telling a smaller version of the big story, and telling it from a personal perspective. It is the photographic equivalent of selecting a few, well-chosen words (rather than a long-winded speech) to make your statement.

"TELL A SMALLER VERSION OF THE BIG STORY, AND TELL IT FROM A PERSONAL PERSPECTIVE."

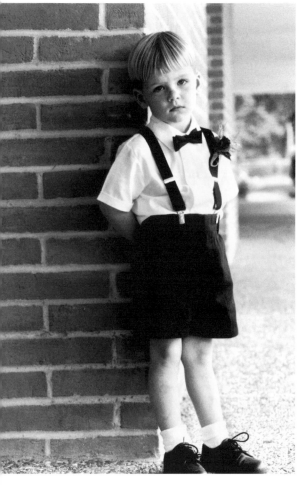

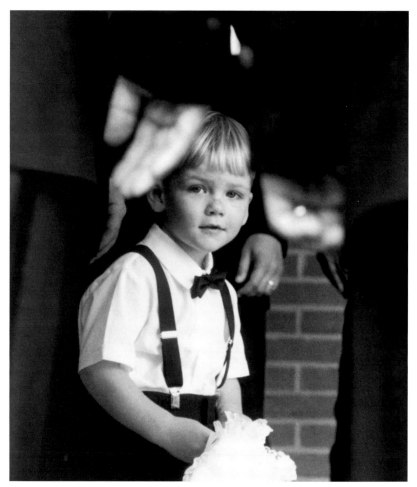

I've been talking a lot about the little girls at a wedding, but boys play a big role, too, and deserve your attention.

The little girls may have fancier clothes and be more caught up the event, but little boys have their own experience of the day.

What could be cuter than this guy? He's dressed to the nines, but still acting very much like a little boy as he leans casually on the corner of the building or peeks out from between the big guys. If you keep your eyes open, you'll probably see lots of chances to catch little boys just being themselves – exploring and playing.

"YOU'LL PROBABLY SEE LOTS OF CHANCES TO CATCH LITTLE BOYS JUST BEING THEMSELVES..."

This is a rather non-descript photograph, but it illustrates one of my favorite stories.

As an only daughter, this bride and her mother share a special relationship – one different than mothers and multiple children.

The bride's mother had saved her christening cap for 23 years so that her duaghter could use it as her handkerchief on her wedding day. This image shows the cutting of the strings from the cap.

When you are shooting this style of photography, one of your biggest assets can simply be keeping quiet and listening. You will hear a lot of valuable information while the bride is getting ready. Listen for clues as to what the bride is most looking forward to, what little details she has specially planned, etc. Knowing these "inside" details will help you immeasurably in recreating the emotion of the day on film.

"...YOUR BIGGEST ASSET CAN SIMPLY BE KEEPING QUIET AND LISTENING."

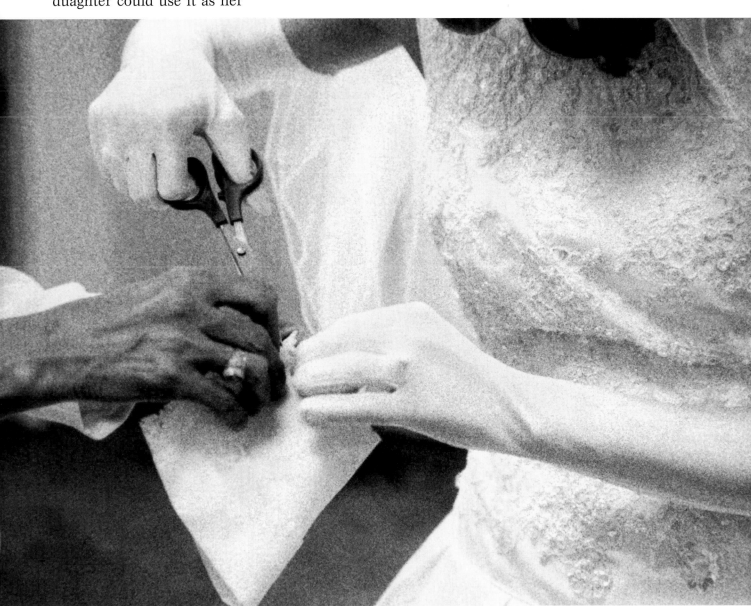

Sculptural Elements

As a lifetime student of art, sculpture is my favorite form. In turn, I bring to my photography a desire to find elements that resemble sculpture and represent them as such.

As you can see, in shooting "sculptural" elements, I do not look for "sculpture" per se, but rather for elements which I can render in a sculptural manner.

I look for those elements which, like sculpture, display an elegance of form and composition, while capturing the essence of the subject. These could be details like folds in the gown, wrinkles in a glove, or the flow of the veil – any element which makes a strong statement about the whole.

Sculptures of the human form display the subject in a way which captures its beauty (or sometimes its flaws) in a way that communicates the idea on an intrinsically human level. With brides, beauty is the name of the game, so I look for ways to shoot the bride as a pure symbol of feminine beauty.

Some brides may have perfect bodies and flawless faces, and with them this may be especially easy. But every bride has an inner and outer beauty that can be captured by the observant photographer. Try photographing the bride's shoulders, the curve of her waist, the nape of her neck, her pearls through her veil. These are shots that, with almost every bride, will produce very pleasing results.

"... DISPLAY AN ELEGANCE OF FORM AND COMPOSITION, WHILE CAPTURING THE ESSENCE OF THE SUBJECT."

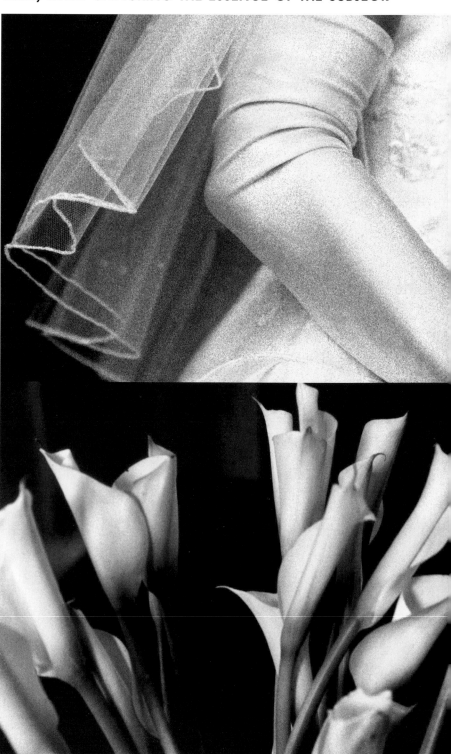

40

Selective Focus

Selective focus is popular artistic technique in photography whereby the photographer intentionally combines focused and unfocused areas in one image.

This can be an effective technique to add to your photojournalistic wedding photography.

Use the focused areas to lead your viewers' eyes and minds into the images; lead them into a room or captivate them with your subject. Then let the unfocused areas engage their imaginations and contribute to the fantasy-like quality of the wedding

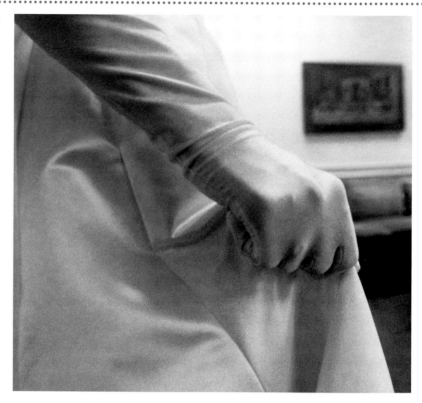

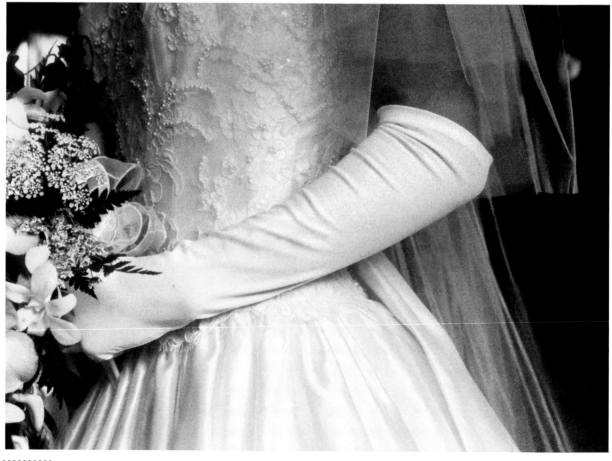

To give you a sense of how my husband and I shoot at weddings, I'd like to walk you through part of one particular day.

Since my husband usually makes all the arrangements and has all the pre-wedding contact with the couple, I am virtually a stranger when the wedding day arrives. I am always surprised, though, at how quickly I am able to form a relationship with the bride and her family. I think it is the highly-charged emotional atmosphere that brings us together so quickly.

This particular close-knit family whom I want to introduce consisted of a mother, father and two sisters. The older sister was the bride, and the younger sister was her maid of honor. Their level of intimacy was something I had never before had the pleasure to witness. Their close relationship was beautiful to watch (and just a little bit overwhelming for the groom!). They lived, played, laughed and cried together –

"THEIR CLOSE RELATIONSHIP WAS BEAUTIFUL TO WATCH…"

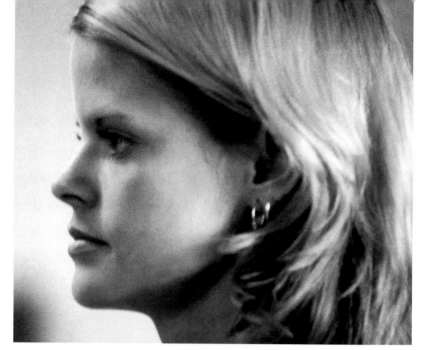

indeed, it was even a little overwhelming for me to see such a tight emotional bond.

Observing relationships like these has a huge impact on the strategy I take when photographing, and how I select the subjects I will shoot. Because the bride's sister was obviously such an important part of the wedding (both in her role as maid of honor and best friend), it was important for me to spend some extra time photographing her.

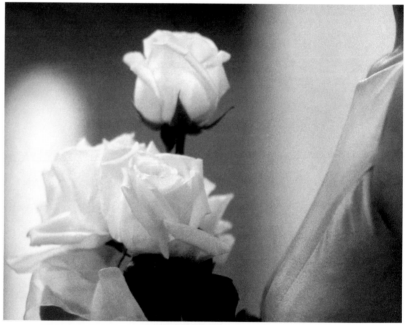

As I've said, my husband does the formal portraits, so this was not the look I wanted to capture. I wanted to create, instead, a series that captured more of the woman than just how she looked. It's been said that a picture says a thousand words – but since I have a series of pictures to work with, I try to be subtle and let each one just whisper a few words.

"OBSERVING RELATION-SHIPS LIKE THESE HAS A HUGE IMPACT ON THE STRATEGY I TAKE WHEN PHOTOGRAPHING..."

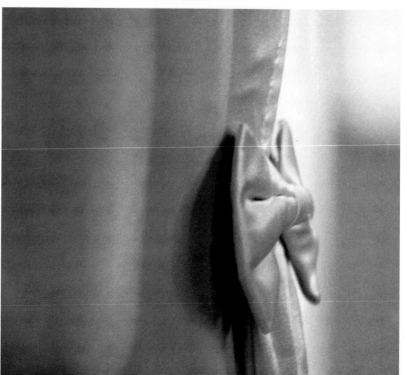

That said, I photographed the sister in sections. The first thing that caught my attention was her pretty face, so I shot this profile (opposite page, top). I also loved the bouquet she was holding, and the way she held it close to her body (opposite page, center). Finally, I observed and photographed the gentle curve of her back (accented with the satin bow on her dress) to complete the series (opposite page, bottom).

The bride herself was tall and thin. She was comfortable with herself (as you can see in her natural smile in the portrait on page 43), and

"THE FIRST THING THAT CAUGHT MY ATTENTION WAS HER PRETTY FACE..."

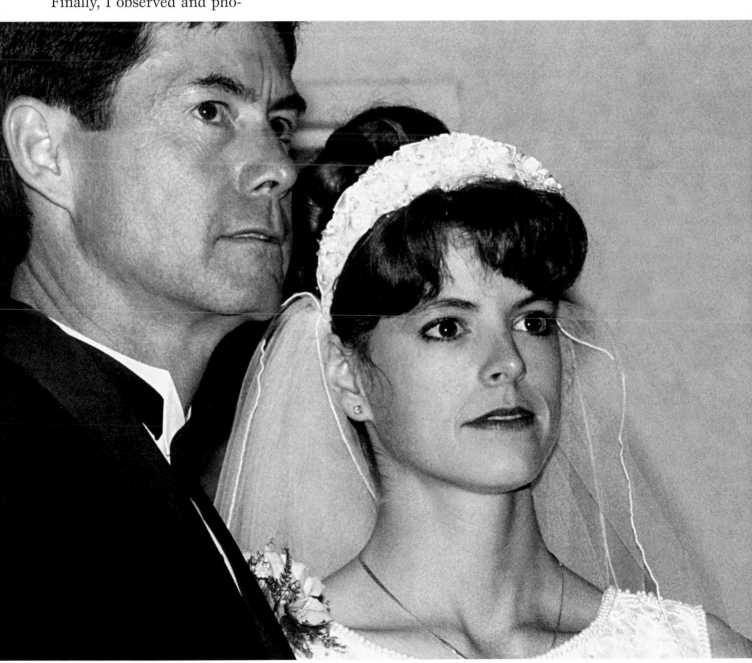

very easy to work with throughout the day.

Having photographed her sister, I still kept my ears open for other "inside tips" that might help me predict what other special moments might occur, which people were most important to Brooke, etc.

What I learned was that everyone thought that Brooke's father would probably lose control of his emotions at some point during the day. Again, this is a great example of why I do very little talking but a lot of listening when I'm shooting.

With the rumor I'd heard in mind, I kept a close eye on Brooke's dad before and during the ceremony. He did very well until it was time for his daughter to leave the reception. I was ready. The series of images to the right were taken with my 80-200mm lens, with the flash on the camera, which allowed me to capture their emotions while giving them the space they needed. I usually do not use a flash, but in the case it was absolutely necessary.

"I STILL KEPT MY EARS OPEN FOR OTHER 'INSIDE TIPS'…"

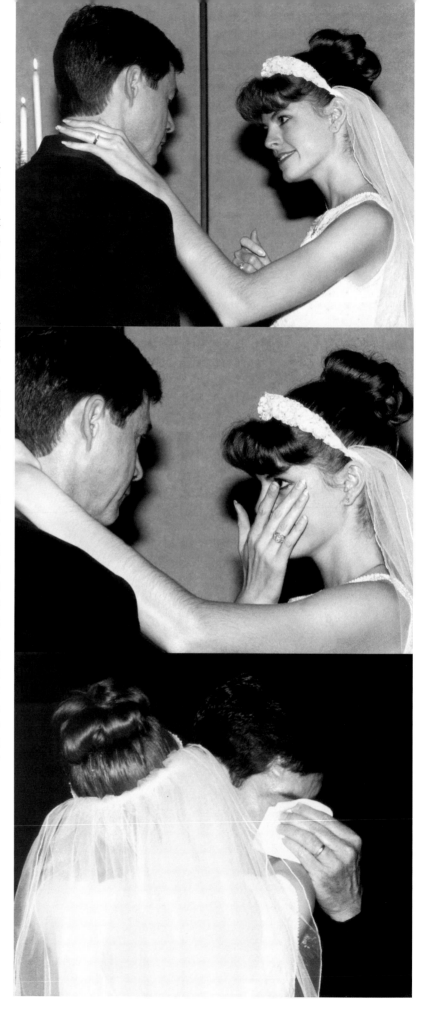

Although I do photograph the groom, he is generally not my main concern at a wedding. Probably, this is for the same reason that I have a more sensitive eye than most men do to the what goes on in the bride's dressing room. The groom and groomsmen's behavior just seems as odd to me as the bride's behavior might to a male photographer. When I shoot the guys before the wedding, I usually get some smart-aleck comment like "Hey, I think your lens cap is on." At that point, I hand the camera to Doug and leave it to him to get a few interesting shots of the guys in their dressing room and leave it at that.

Later, after the ceremony, I include the the groom in photography of the bride, but more as an accessory. This is not to say that I don't think the groom is important (obviously this is a big day for him too), but the bride is the star, so I generally favor her above everyone.

My best shots of the groom have generally come when I catch him at just the right moment – moments when he's just being himself. In this way, photographing the groom is not much different than photographing the bride. In both cases, I try to catch them in natural moments that reveal who they really are. I just find that a little harder to do with the men.

"I TRY TO CATCH THEM IN NATURAL MOMENTS THAT REVEAL WHO THEY REALLY ARE."

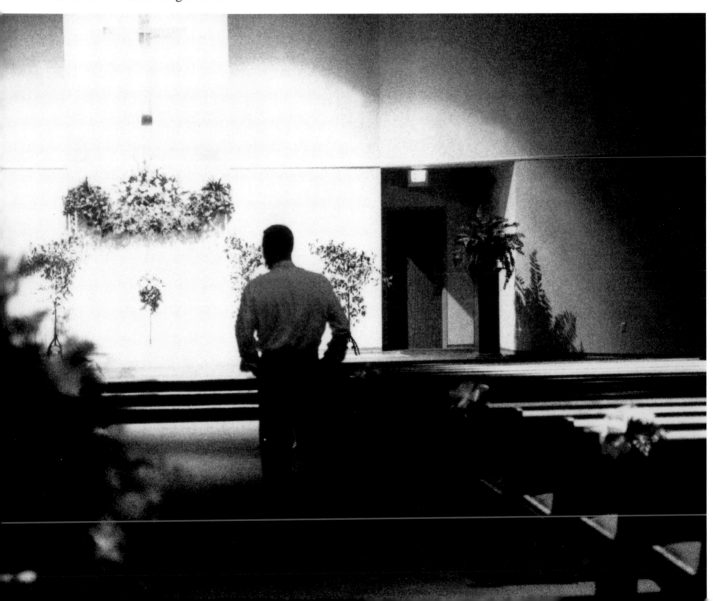

In the instance shown on the previous page, this natural moment came when the groom wandered away from the crowd to take a few quiet minutes to himself. I watched him leave his dressing room and enter the sanctuary. I took one shot and then left him to his private thoughts as the moment of his nuptials approached.

"ONE GREAT EXPRESSION AND GESTURE IN A SEA OF SERIOUS FACES MAKES THIS IMAGE WORK."

Sometimes a wonderful image of the groom and his groomsmen also occurs when you catch them in a group. In the right-hand image below, one great expression and gesture in a sea of serious faces makes this image work. A tilt of the camera and shooting from quite low angle adds interest to the composition, as does

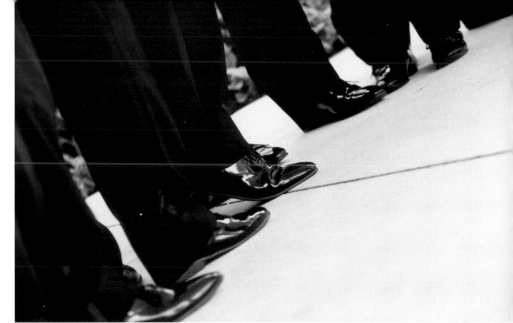

the little guy's face in the lower corner.

As with brides, I try to capture some of the details of the groom's clothing. Opposite left, a hand in a pocket and a tilted camera show off this gentleman's elegant tuxedo. Above right, a row of shiny shoes captures the day's formal side.

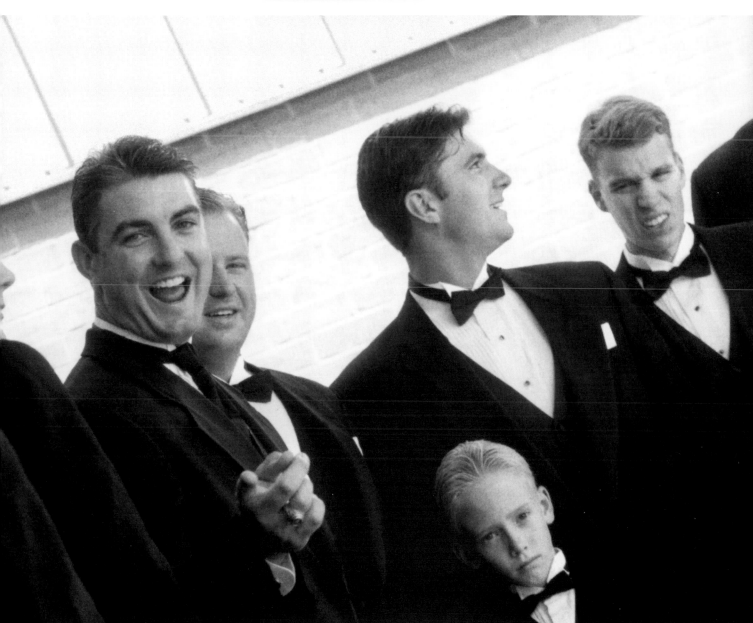

The Bridesmaids

The bride has chosen her bridesmaids carefully. They are her closest friends, sisters and relatives. They have helped make her who she is, and have watched her relationship with her soon-to-be husband grow and flourish. They know all the details of the couple's relationship and are therefore especially connected emotionally with the bride. This alone makes them important people at the wedding.

"THEY HAVE WATCHED HER RELATIONSHIP WITH HER SOON-TO-BE HUSBAND GROW AND FLOURISH."

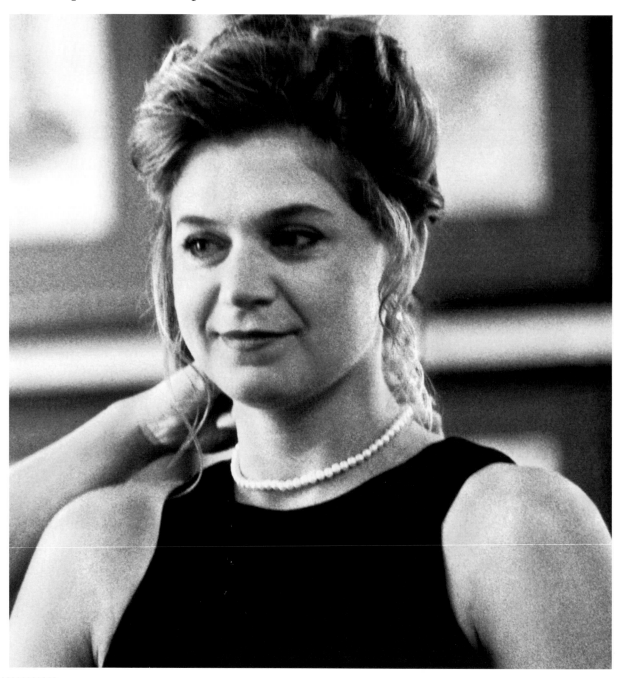

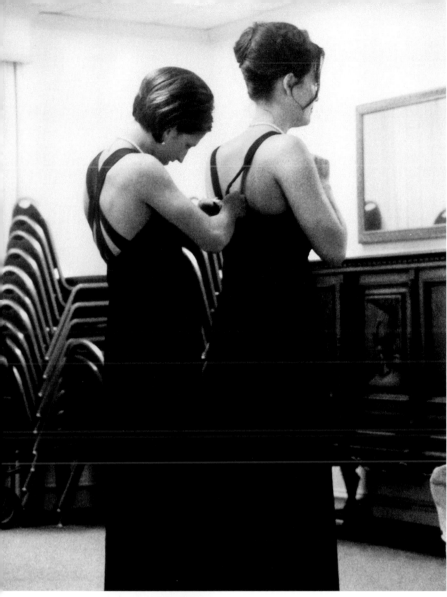

The bridesmaids also help to make the dressing room a fun and interesting place to shoot before the wedding. The bridesmaids usually interact well with each other, so I watch for chances to shoot them helping each other zip up their dresses, put on jewelry and generally laughing and enjoying each other's company.

I also tend to photograph the bridesmaids as I do the bride – especially when they are getting dressed and getting their hair and make-up done.

I additionally look for good close-up shots – their hair from the back, their shoes and bouquets, for example. I look for all those elements that help explain and depict the day to its fullest.

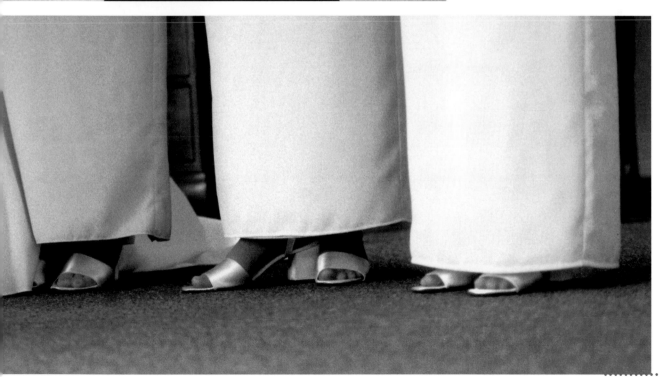

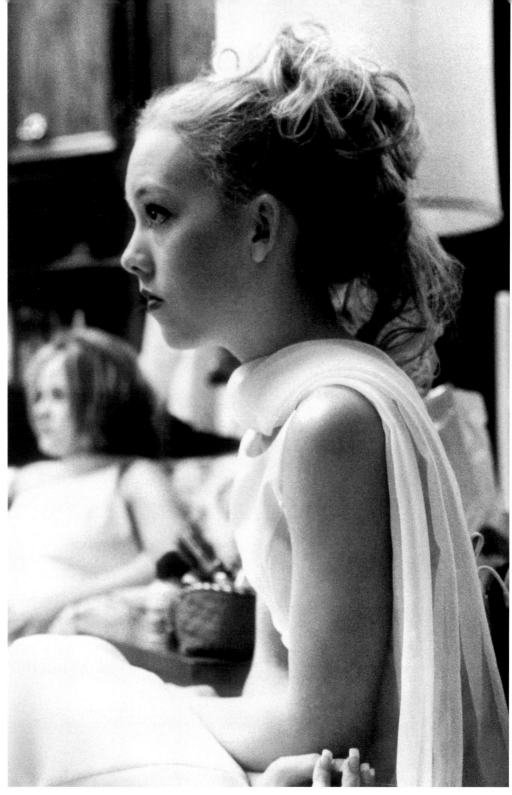

Keep in mind that brides usually give each bridesmaid a gift. Usually it's a piece of jewelry to wear during the ceremony. This is one of the special touches that makes each wedding unique. Again, it's something the bride has carefully chosen, so a nice image of the gift will be appreciated.

I also find that the bridesmaids are a good source of information throughout the day (especially if a wedding consultant is not available). Usually I will find that one of them is especially approachable and friendly, so I'll seek her out when I have questions about what is going on, or need some information on family members and friends. This is the bride's day, so I try not to approach her directly with

questions – after all, she has quite enough on her mind already.

As I shoot the bridesmaids throughout the day, I am always on the lookout for unique lighting situations Below, for instance, the directional quality of the window light showed off the texture of the bridesmaid's dress very well (as if the cute situation wasn't enough to make the photo special).

Working with black & white film (I use Kodak TMZ 3200) for this style of photography is great because you can shoot in any type of light. Some of the photos in this book were shot in fluorescent (which gives color photos a green tint) or incandescent light (which gives color photos an orange tint). Having to fumble with color compensation filters as I move from room to room, and lighting situation to lighting situation, would make this style of photography impossible.

"… I AM ALWAYS ON THE LOOKOUT FOR UNIQUE LIGHTING SITUATIONS…"

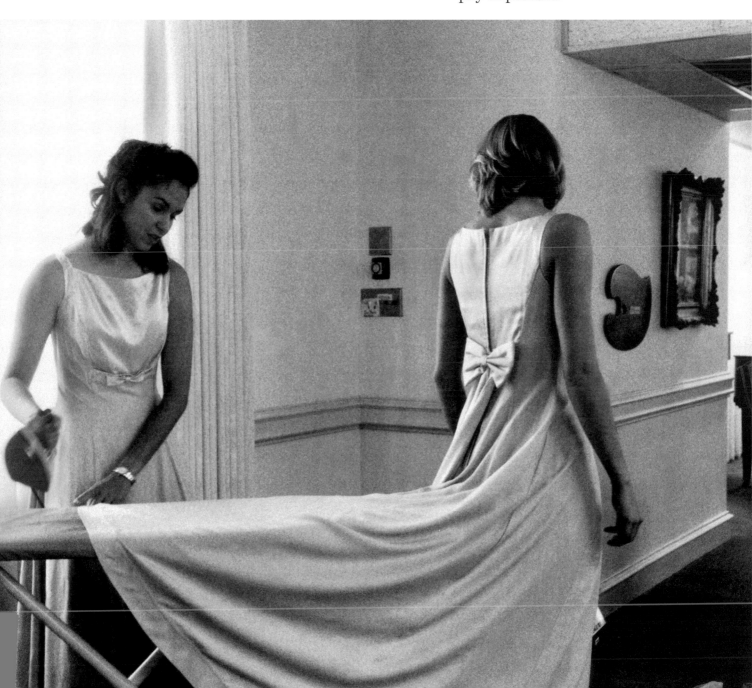

A second benefit of shooting in black & white is its ability to isolate the subjects from the colorful distractions around them. Instead of your eyes being drawn to a bright spot of color (say a colorful bouquet), you look directly at the subject.

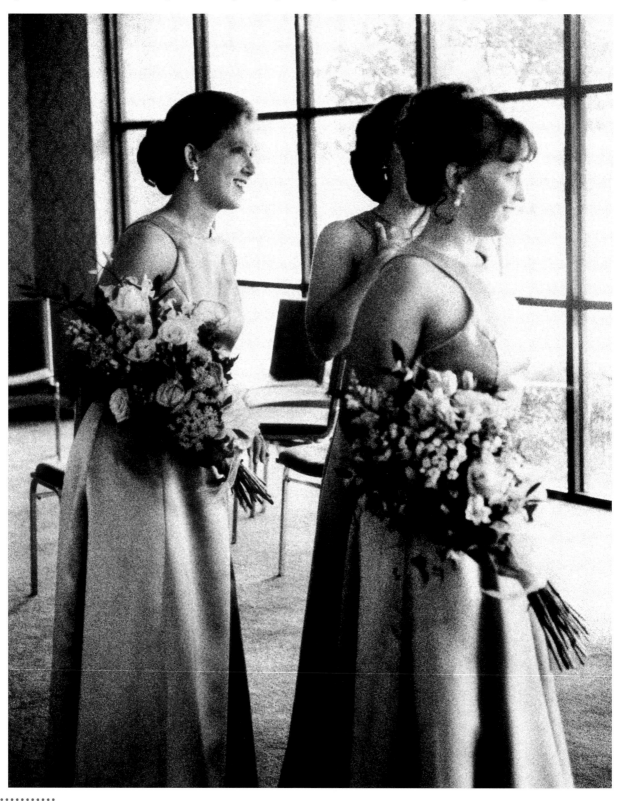

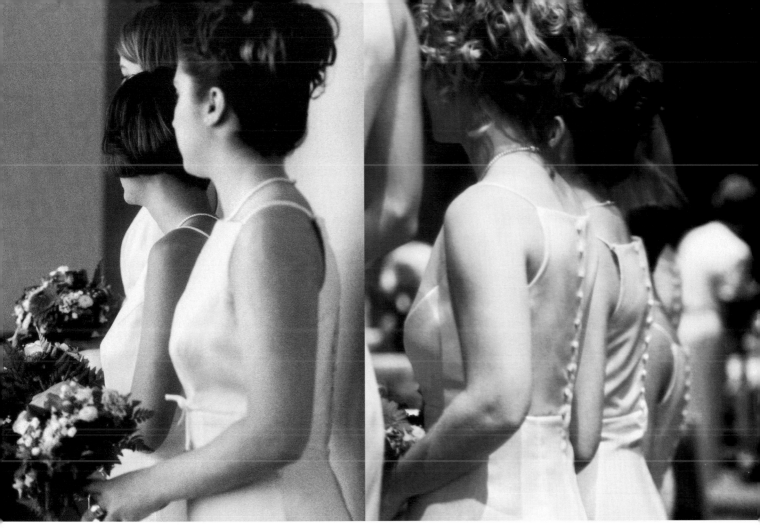

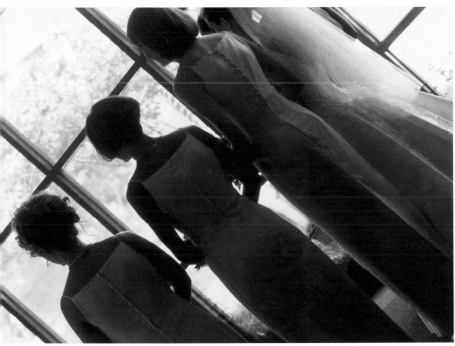

"LOOK BEHIND YOU, PEEK AROUND CORNERS, SEARCH THE HALLS..."

guard and anticipating the action. You must be totally comfortable with your camera, and ready to move from situation to situation, then shoot there almost without thinking.

In some ways, story-telling is harder than the traditional style of wedding photography. Instead of orchestrating your images carefully with each subject posed and careful attention paid to lighting,

Look behind you, peek around corners, search the halls and always keep your eyes open and your camera ready. To be sure you are ready to catch the moment when it happens, you always have to be on your

55

you must work on the fly. There is no set routine since you are always on the move, searching for meaningful events.

You can't make these images happen, and that "realness" is part of their beauty. With some practice, you can learn to switch gears. You will be surprised at how attuned your eye can become to these wonderful images that previously had passed you by. Again, try thinking like a bride. What is important to her?

"YOU CAN'T MAKE THESE IMAGES HAPPEN, AND THAT 'REALNESS' IS PART OF THEIR BEAUTY."

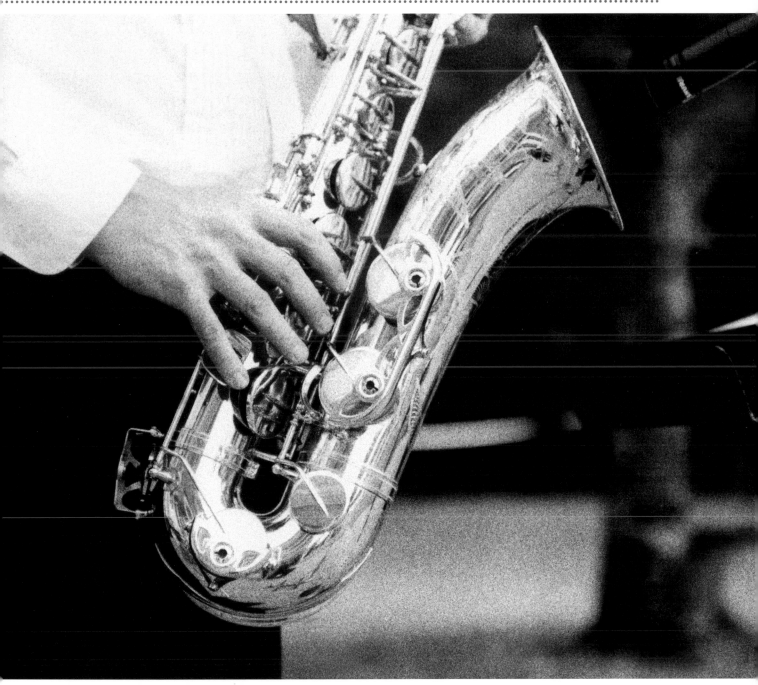

Most couples choose the music for their wedding day together. They select pieces that are meaningful to them and which they feel represent their relationship, the way they feel about each other, and the commitment they are making to each other on this day.

This makes the music a very special part of the ceremony, and an especially meaningful event to the couple. It also means it's a wonderful thing for you to help them

"MOST COUPLES CHOOSE THE MUSIC FOR THEIR WEDDING DAY TOGETHER."

remember in your images of the day. Don't miss the opportunity to include it in their final wedding album.

Obviously, you can't shoot the sound itself, but opportunities abound to capture reminders of it. I like to shoot photographs of the sheet music when possible, the individual instruments, or even the entire quartet or group of musicians.

When the bride and groom look at their final album, I want them to see these images and be able to hear that special song in their heads.

"I WANT THEM TO BE ABLE TO HEAR THAT SPECIAL SONG IN THEIR HEADS."

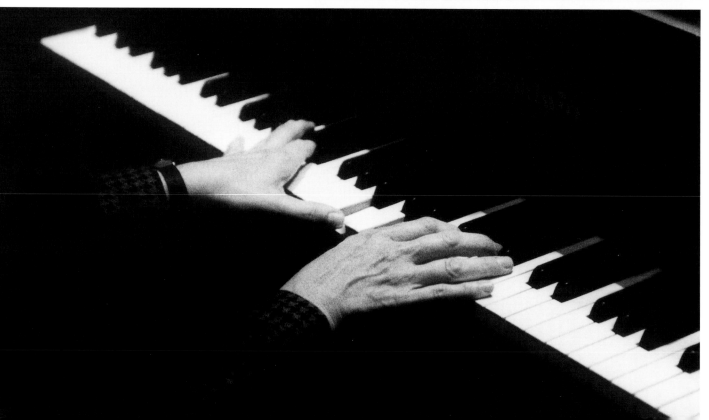

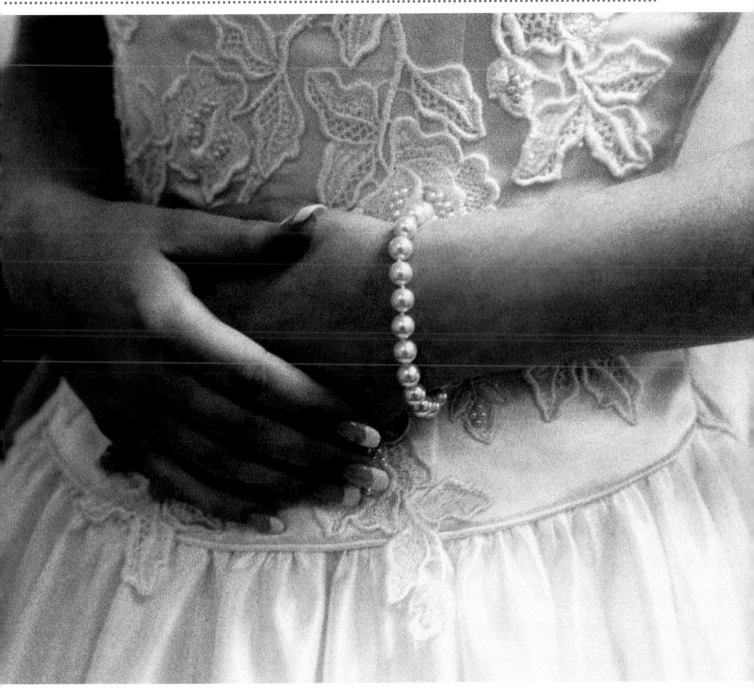

Most brides are nervous – this is just something that comes with the territory. Even aside from the huge commitment she is about to make, the bride has invested a lot of time and effort planning a special day for everyone involved. She'll be worried about everyone arriving on time, the flowers, her dress looking perfect. Will the ceremony goes as planned? Will she cry? Forget her vows? Will every-

"WILL THE CEREMONY GOES AS PLANNED? WILL SHE CRY? FORGET HER VOWS?"

one have a good time at the reception? This is why I try to work with one of her bridesmaids or the wedding planner when I have questions.

Nervousness is a natural and indicative part of the wedding day. If you can capture it in a sensitive way (giving the bride the space she needs to calm herself), images of this emotion can be a great addition to the couple's wedding album.

I caught the image of the bride on the previous page just before we started shooting the formal portraits. She was trying to hide her anxiety by taking a deep breath while holding her stomach.

The image on this page was taken during the special time that some of our brides choose to have two hours before the wedding. We clear the sanctuary and place the groom at the altar where he will stand during the ceremony. Then the bride enters the rear of the church and walks down to her waiting groom. We leave the couple alone for five to ten minutes. This time spent alone has an incredible calming effect on both of them and sets a calm and happy tone for the entire rest of the day. It helps them to focus on each other, and know that each is there for the other.

Using a telephoto lens (so as not to intrude), I usually take several images from a distance during the first few seconds of this meeting. Then I leave the couple alone for their private time.

"THIS TIME SPENT ALONE HAS AN INCREDIBLE CALMING EFFECT ON BOTH OF THEM..."

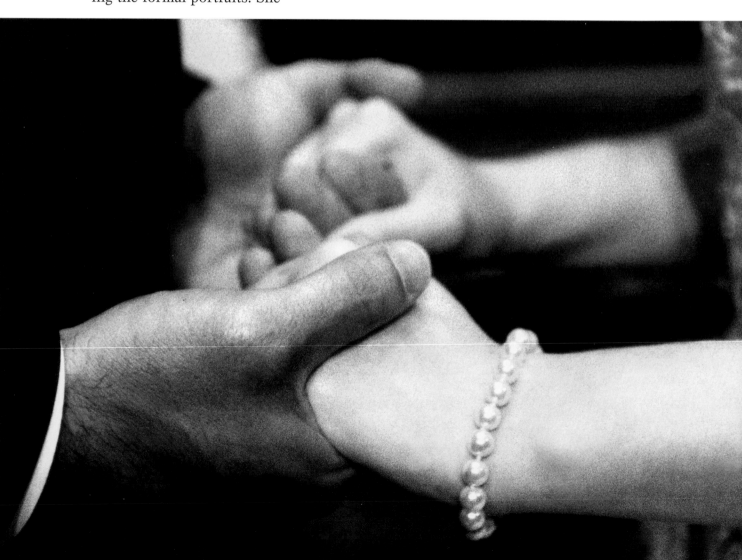

Since most wedding days are a flurry of action, I love to include a sense of movement in my images of them.

I also like the way that showing movement helps convey the idea that the bride and groom are moving into a new phase of their life marked by this day.

Finally, I will be combining these photos with traditional posed images in the final album. Because of this, adding motion to my storytelling photos makes the album feel even more diverse. It really communicates the fact that these two types of photos are showing all the different aspects of the bride's wedding day.

"... MOST WEDDING DAYS ARE A FLURRY OF ACTION..."

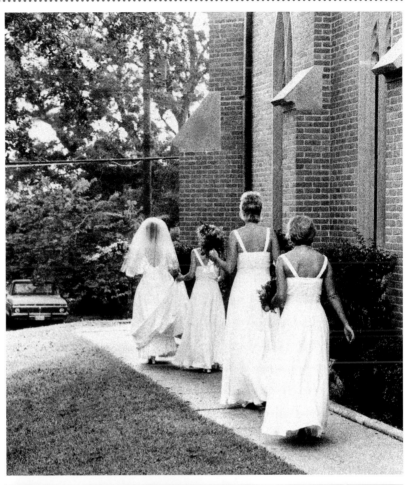

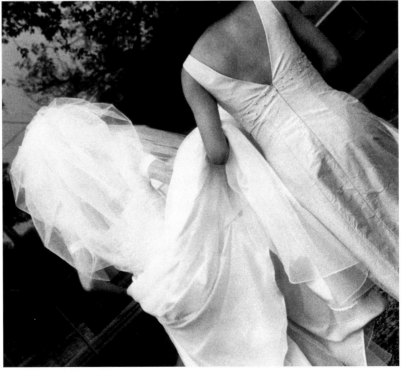

The Ceremony

The ceremony is the focal point and main event of the day. There are a lot of aspects of it to keep in mind when shooting.

First, months of planning (every detail from the church right down to the nail polish) and years of dreaming all culminate in this event. When once she felt like the day would never arrive, now all the time seems to have rushed by so quickly. Capture the details so she can enjoy them later in her album (on a more relaxed day when all the anxiety has passed).

Second, the time it takes from when the bride walks down the aisle until she walks back up it on the arm of her new husband passes in a matter of minutes. If it all seems like a blur to me, it must be even more so to the bride! Therefore, I try to capture the little details she might not have had time to notice during the ceremony.

Finally, I always work with a telephoto lens and stay back from the action. Before any shooting happens during the ceremony, the photographer should speak with the person performing the ceremony to determine any restrictions (parts of the ceremony during which photos are not permitted, whether flash is prohibited, etc.). Remember, the ceremony is a religious event and should be photographed with caution not to cause distraction to the couple or the audience. It is imperative that you are careful to shoot respectfully.

"IF IT ALL SEEMS LIKE A BLUR TO ME, IT MUST BE EVEN MORE SO TO THE BRIDE!"

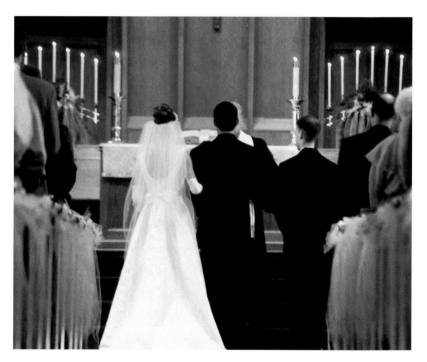

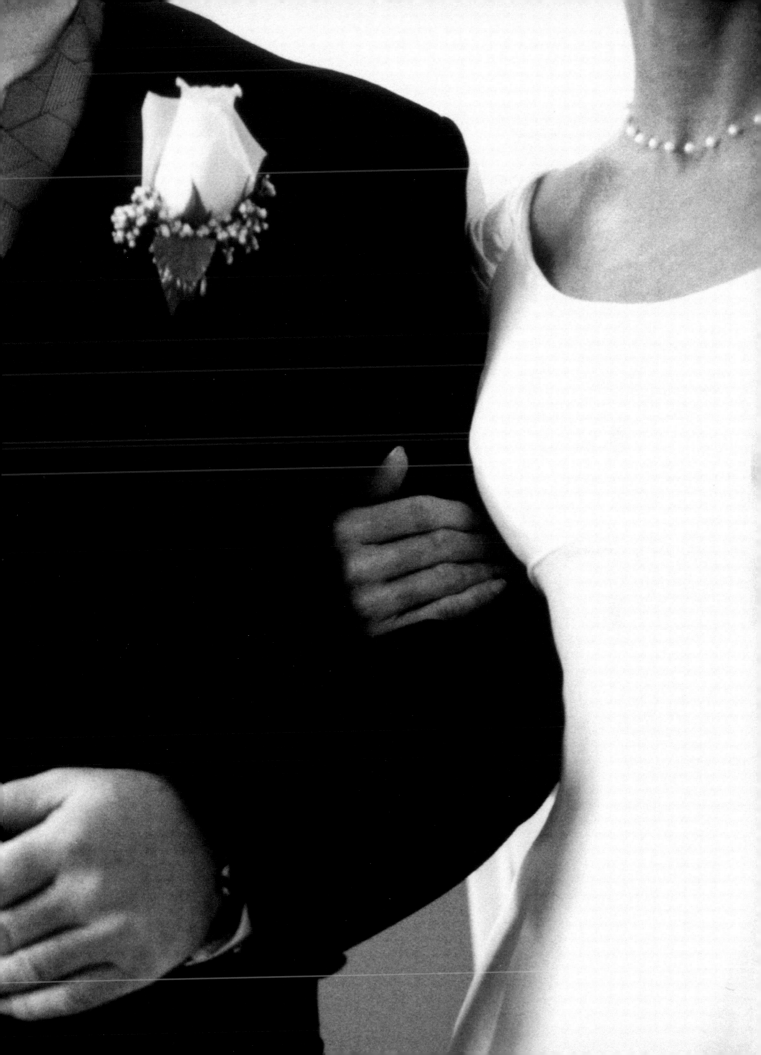

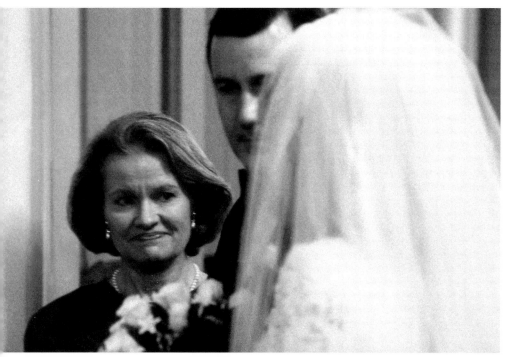

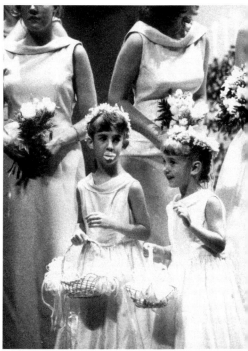

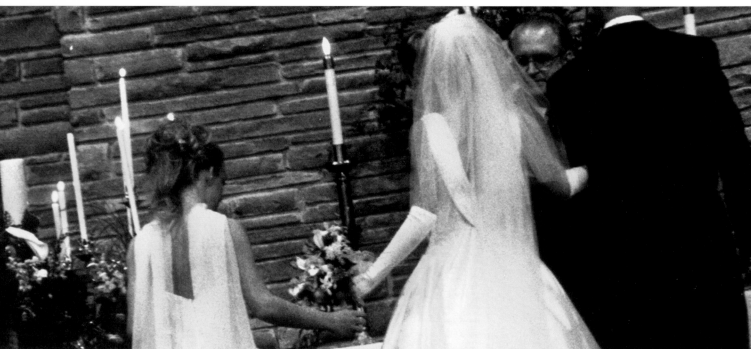

Some of the moments I look for are: the reactions of people around the couple to the ceremony; the behavior of the children in the wedding (which can be very interesting), and the way the bride hands her bouquet off to the maid of honor.

As I mentioned in my discussion of the veil, I also look for cute shots when the father raises the veil to give the bride a good-bye kiss, and when the groom lifts it to kiss her hello.

The ring exchange is generally the only type of image that we stage. It's such a meaningful and representative part of the day, and I think that close-ups are just so much more intimate than a telephoto shot from the back of the church.

Although these images are posed, we take care to make them look natural and authentic. As you can see, by framing the images tightly I can create a look that is very genuine.

" ... CLOSE-UPS ARE JUST SO MUCH MORE INTIMATE..."

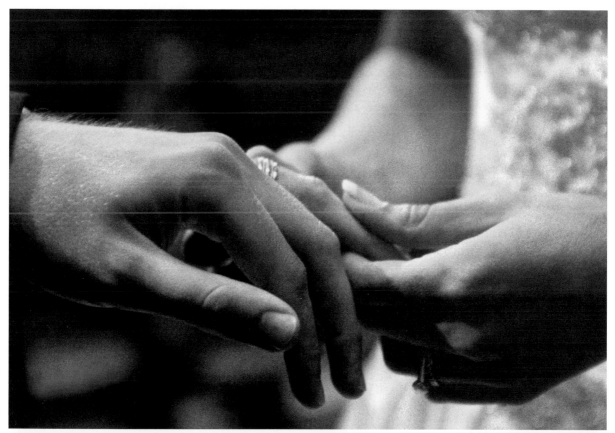

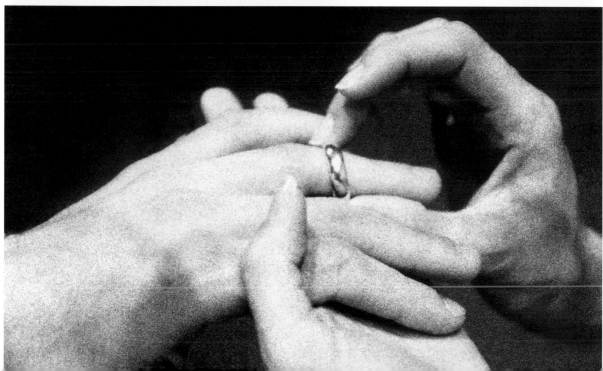

Bustling

After the ceremony, a flurry of activity takes place. One of the most exciting events is the bustling of the wedding dress. Bustling pulls the train of the gown up into a carefully gathered puff of fabric (the bustle) at the top of the skirt in the back. This allows the bride to move around without soiling the train (or tripping on it).

The bustling of the gown makes a great action shot since it takes several people to do it. The key to the shot is getting close enough to show the tiny buttons they are trying to manipulate.

"THE BUSTLING OF THE GOWN MAKES A GREAT ACTION SHOT SINCE IT TAKES SEVERAL PEOPLE TO DO IT."

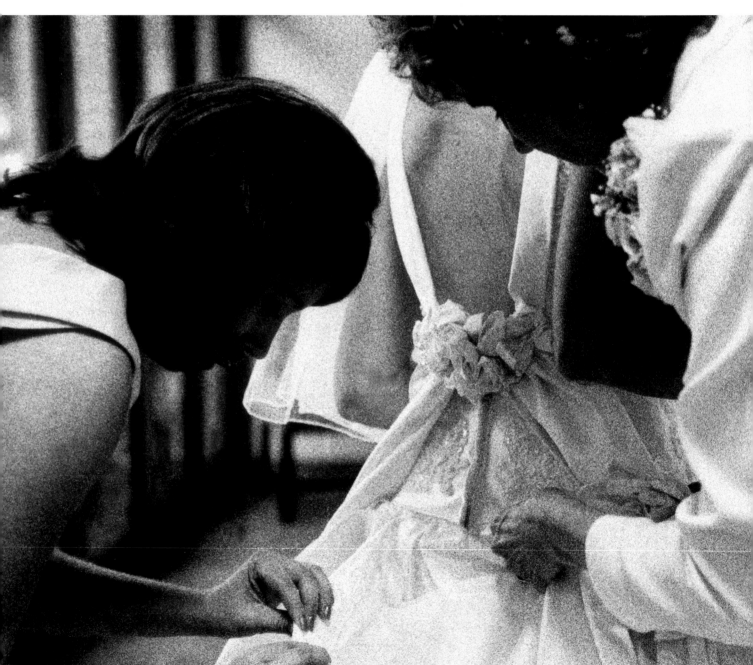

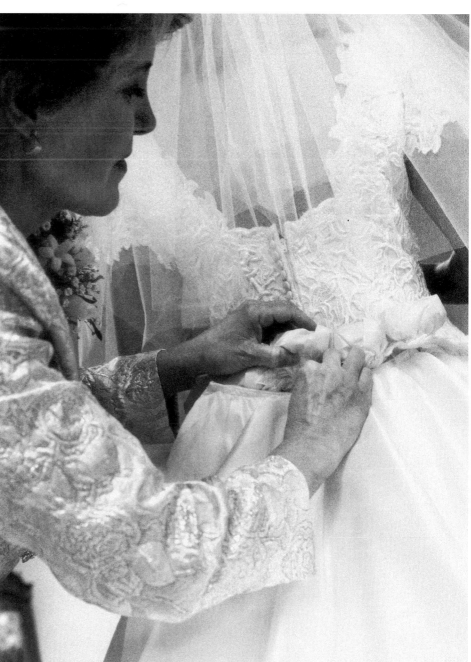

Show the buttons, the tiny loops that attach to them and the hands that are doing the detailed work.

Usually the honor falls to the mother or the maid of honor (and occasionally the groom in rare instances). In the image below, even the caterer joined in – now that's service!

"SHOW THE BUTTONS, THE TINY LOOPS THAT ATTACH TO THEM..."

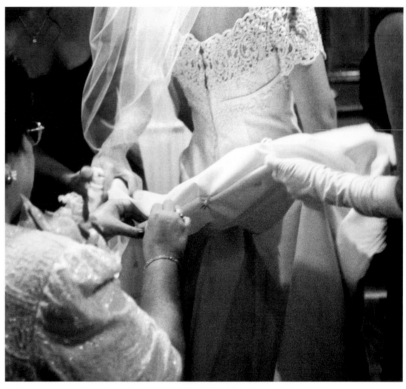

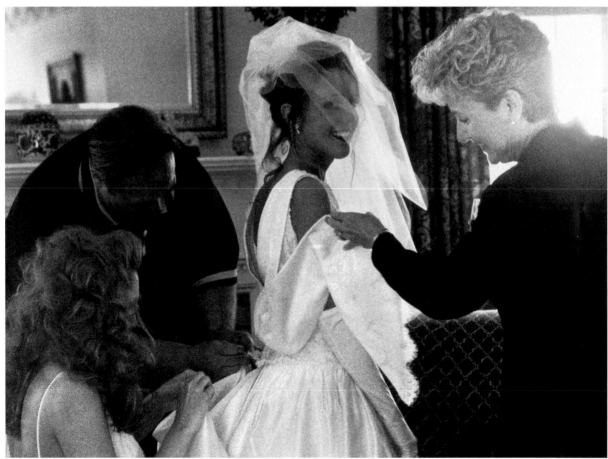

Once the pressure of the ceremony is over and the anxiety starts to evaporate, you can start to catch the couple just being two people in love.

They are also two people who know each other very well, so watch how they interact, how comfortable they are with each other.

Observe and photograph the little gestures they exchange Watch for shots that show the way they kiss, how they hold hands. Watch for her to adjust his tie, or him to help her with an earring.

Try to capture the romance of the day, and the romance of the couple. As always, don't let up on photographing those carefully planned details (like her bouquet) and looking for great light.

"... YOU CAN START TO CATCH THE COUPLE JUST BEING TWO PEOPLE IN LOVE."

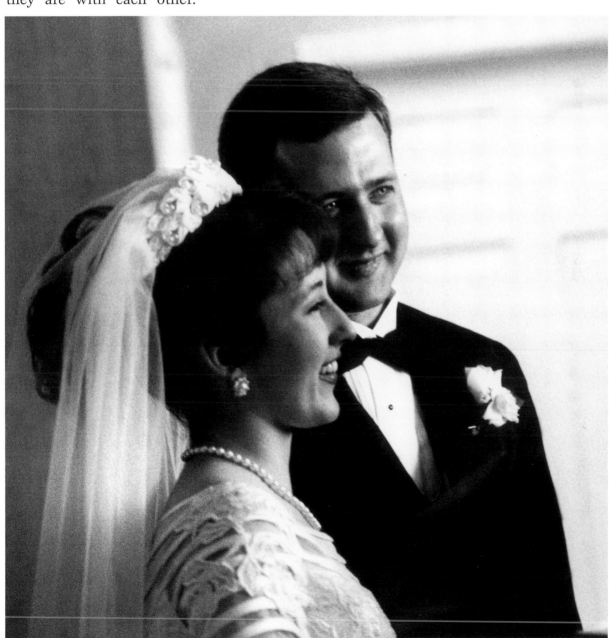

The following pages show some of my favorite shots. All were shot in a photo-journalistic style while I was observing the couple after the ceremony.

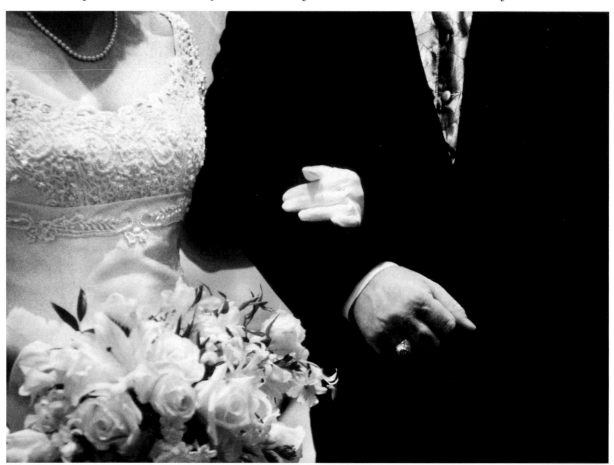

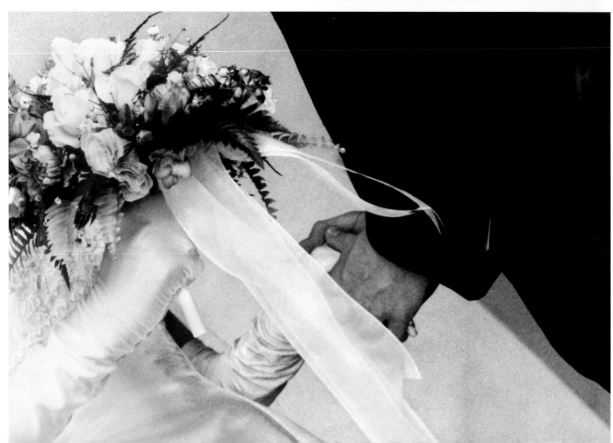

Notice how a low camera angle alone (opposite page, top), or a low camera angle combined with a camera tilt (opposite page, bottom) contribute to the strength of the composition.

Right, the groom helps the bride with her jewelry. It's a familiar and loving gesture that says much more about their relationship than most traditional portraits.

Below, the bride and groom kiss on a lovely stone porch. Notice how the directional quality of the light livens up the picture and helps show more shape than non-directional light.

"IT'S A FAMILIAR AND LOVING GESTURE..."

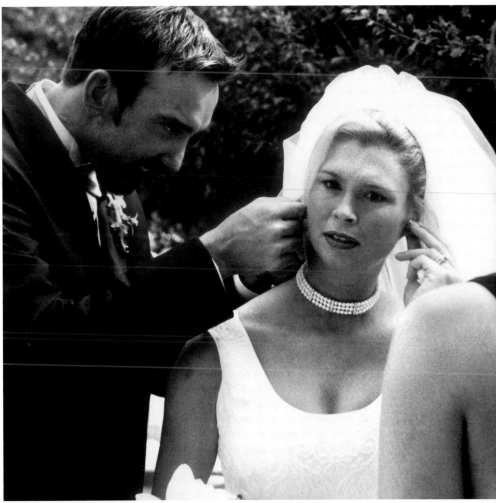

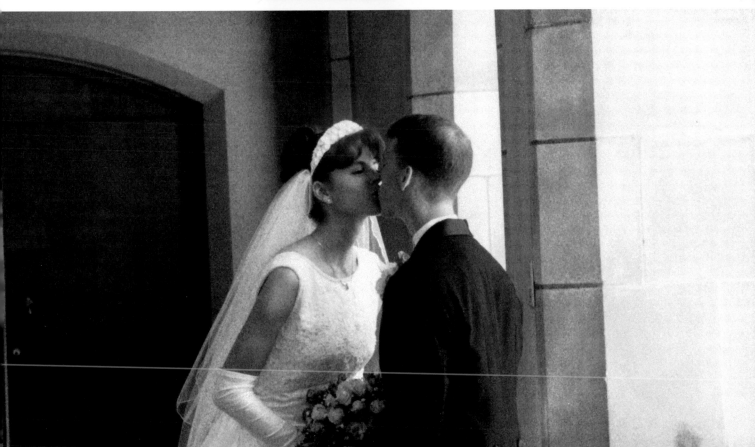

"... THE FIRST TIME THE BRIDE AND GROOM HAVE BEEN TOGETHER AS MAN AND WIFE."

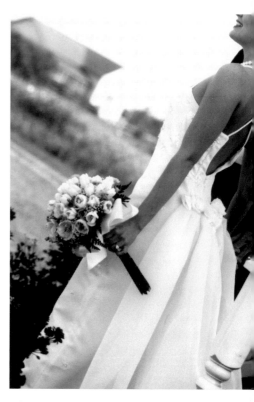

The hours following the ceremony are the first time the bride and groom have been together as man and wife. As you can see from these images, it's a romantic time when the couple is happy and surrounded by all their friends and family. The key, again, is to catch them at moments when they are just being themselves.

Throughout the day you'll have opportunities to portray this more intimate side of the event – but you have to be looking for the moment and ready to shoot it when it happens.

This is also a great time to shoot a series of images that, in a sense, "narrate" a few of the first moments in the couple's married life. Both this page and the following show three pictures from

such a series of images. All were shot outdoors while watching the couple interact.

It's not always important to show the faces. There will be hundreds of pictures of the couple's faces from the wedding. How many will show the way the groom put his hand on his new wife's waist, or how she touched his lapel?

"IT'S NOT ALWAYS IMPORTANT TO SHOW THE FACES…"

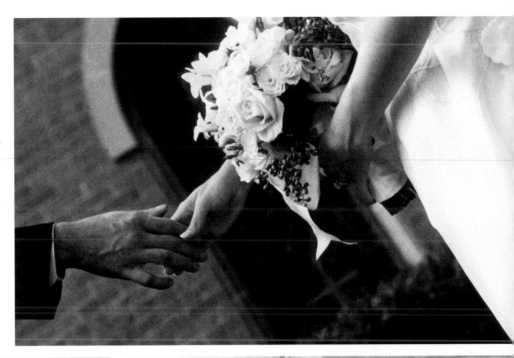

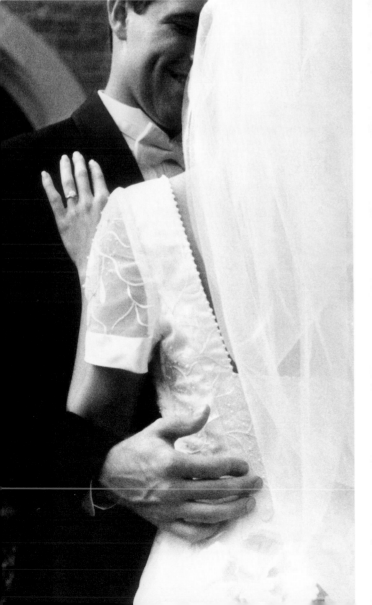

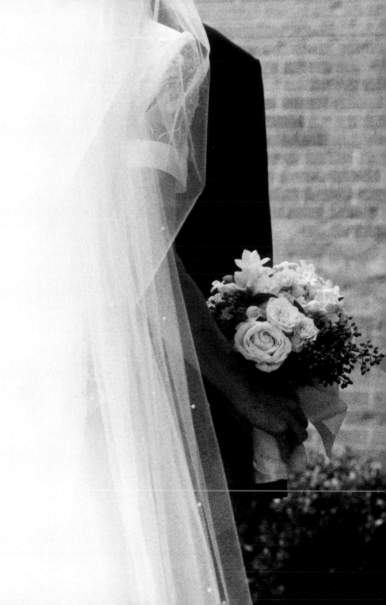

Timing is Everything

I've said it before and I'll say it again – in storytelling photography, timing is everything.

Here's a perfect example. Looking at these two totally bored bridesmaids on the left, you'd never guess that the shot on the right was taken just a few seconds later. What a change in mood, and what a priceless shot of two of the special people the bride picked to stand up in her wedding!

Again, it happened only because I was there, paying attention and ready to shoot. Proof positive that it pays to keep your eyes open even when things look a little, well, boring.

"WHAT A CHANGE IN MOOD, AND WHAT A PRICELESS SHOT..."

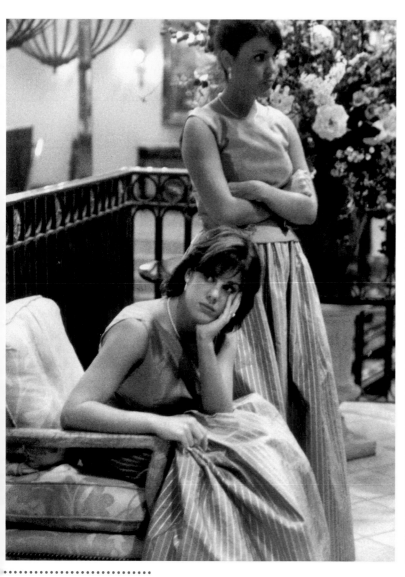

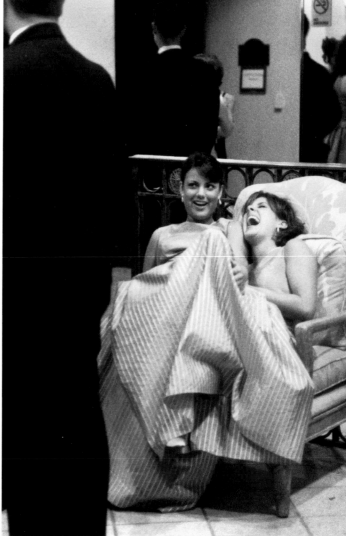

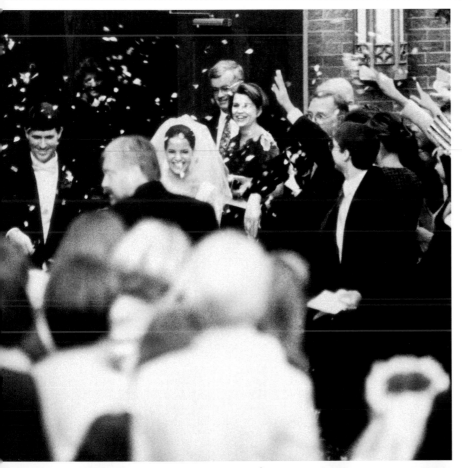

When the ceremony is over, the celebration has just begun!

In the top photo, rose petals are flying and guests are clapping. It's one of the most exciting events of the day when the couple leaves the church. From across the street, I caught the action with a long lens (80-200mm set on 200mm) so I could get in close on the action.

Below, leaving in the car, the couple exudes happiness as they look forward to their party and their future (usually in that order).

"ROSE PETALS ARE FLYING, GUESTS ARE CLAPPING…"

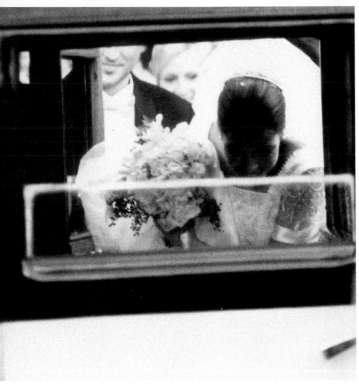

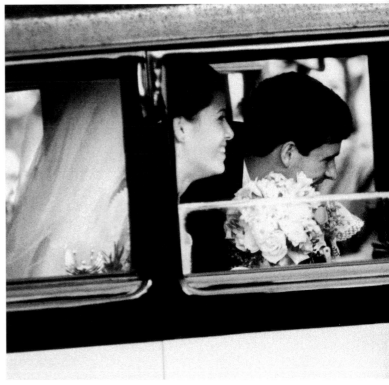

The Reception

Since I do most of my work with available light, the majority of my images are with the bride at the church. I do, however shoot some images at the reception as well.

When we first arrive at the reception, I walk around (before most of the guests arrive) and shoot details of the cake, table settings, champagne glasses, any small gifts left for her bridal party, etc.

I also love to get a few shots of the musicians at the reception, as shown here.

It is usually rather dark in the reception hall or country club, so at times I am forced to use flash. Generally, however, I try to avoid the flash and choose a long lens (80-200mm). This lets me work without intruding or spoiling the moment I'm trying to shoot. Being unobtrusive is crucial to capturing great expressions.

"IT IS USUALLY RATHER DARK IN THE RECEPTION HALL OR COUNTRY CLUB..."

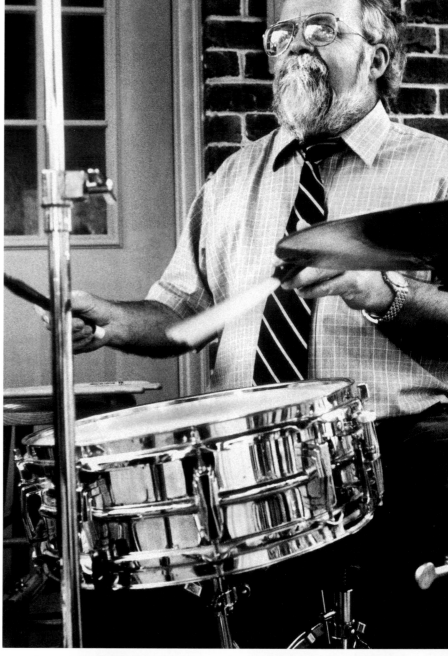

The following are some examples of the great images you can capture at an outdoor reception (using natural light only). These photographs were taken at the reception of Jacy and Craig – a very fun and festive outdoor event.

The bride and her parents had planned the day perfectly. When we arrived at their home for the reception, the sun was just beginning to sink in the western sky. This late-day light is just beautiful for photography.

"THE BRIDE AND HER PARENTS HAD PLANNED THE DAY PERFECTLY."

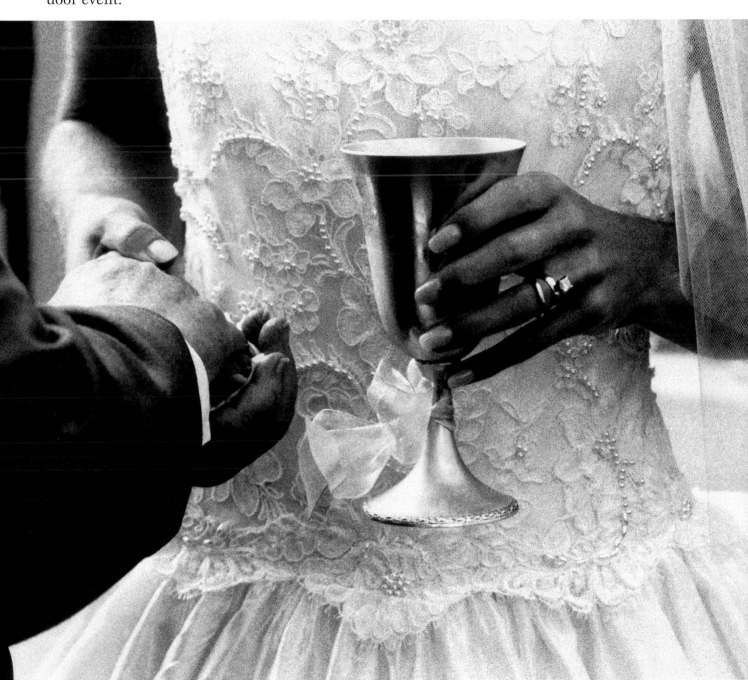

Every detail was perfect – the cakes and champagne were set up outside on a large porch that was about five feet from where the tents were. I positioned myself at this great vantage point and shot one great candid after another. It's a great challenge and a lot of fun to work in such a spontaneous way, capturing your

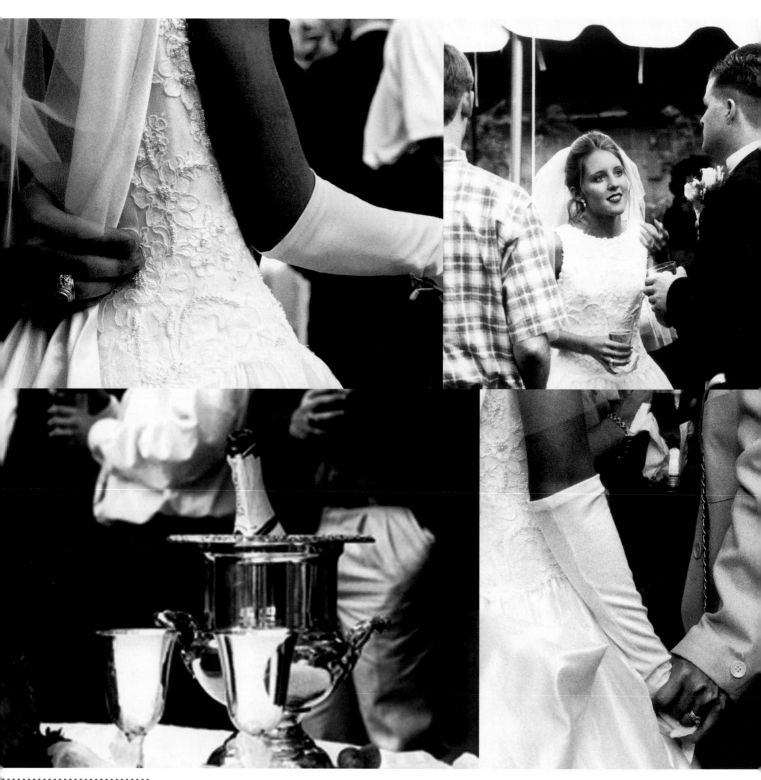

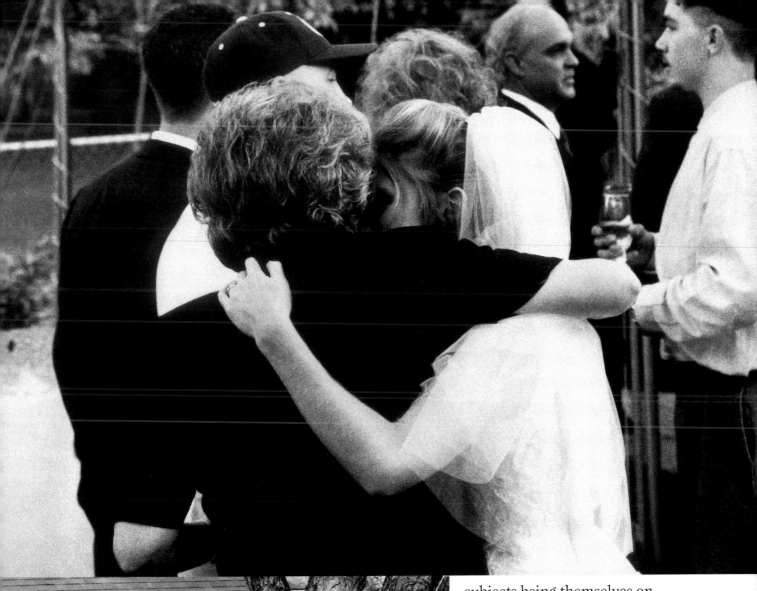

subjects being themselves on a special day.

Most of these small, but important moments would likely have gone unnoticed without such images. Also, keep in mind that the bride can't be everywhere, so your photojournalistic images may even show her a few events she missed.

"SMALL, BUT IMPORTANT MOMENTS WOULD HAVE GONE UNNOTICED..."

Technical Elements

Technically speaking, I use a Nikon 8008s. My main lenses are a 35-70mm (f-2.8) Nikor lens, and an 80-200mm (f-2,8) Nikor lens. I also use a 20mm (f-4) Nikor and a 16mm (f-4) Nikor.

Fast lenses are extremely important for successful storytelling photography. The lenses I use most are f-2.8. At full extension, an f-3.5 to 4.5 lens is 1.5 stops slower than my f-2.8.

To allow me to capture fleeting moments, the camera is

"FAST LENSES ARE EXTREMELY IMPORTANT FOR SUCCESSFUL STORYTELLING PHOTOGRAPHY."

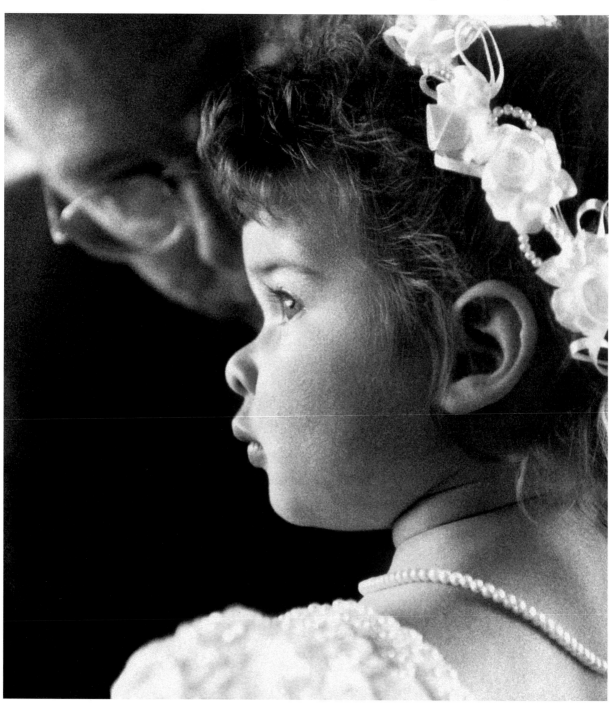

set on auto-focus with auto-exposure matrix metering. The quick focusing ability and accurate metering of the Nikon 8008s are major factors that make it my choice. So many of the moments I photograph last only a split second. If I had to focus manually or wait on slow or inaccurate metering, may of the images in this book would never have been taken.

The film I use is Kodak TMZ 3200, a fast black and white. Why do I choose high speed film instead of the traditional 400 speed black & white? The speed permits me to work in a variety of lighting situations with short exposures (important since I am hand-holding the camera).

The difference between ISO 400 and ISO 1600 (at which I generally rate this film) is two stops. At f-2.8, this means the difference between a 1/15 second exposure (ISO 400) and a 1/60 exposure (ISO 1600).

Your chances of getting an acceptable photograph at 1/15 are much lower than at 1/60. This is especially important with long lenses, when the faster shutter speed is more of a necessity than a luxury. Fast film can mean this difference between getting and losing a shot.

More importantly, fast film allows me to avoid using the flash. Using available light only gives my images a natural quality – very real and spontaneous. Avoiding the flash also allows me to capture people without making them feel self-conscious – I can just blend into the background.

I choose black & white for several reasons. Stylistically, it sets my storytelling images apart from the the traditional color photography in the wedding album. Compositionally, it helps to isolate the subjects and better communicate the very emotions and events I am trying to portray. In terms of light, black & white allows me to avoid having to waste time with color compensation filters. This means I can go from lighting situation to lighting situation almost instantly.

"SO MANY OF THE MOMENTS I PHOTOGRAPH LAST ONLY A SPLIT SECOND..."

I use the Kodak TMZ3200 film in two ways. If I want more grain, I expose it at ISO 3200, then push-process it one stop and print it with #3.5 filter on Kodak PolyMax IRC II paper (E surface). Using the film at this speed produces a beautiful, nostalgic image with a nice grain structure. This is perfect for the emotionally charged, artistic details of the wedding.

For less grain, I rate the film at ISO 1600 and process it regularly (at ISO 1600). This creates a softer look, especially when I am working in a lighting situation with strong contrast. Depending on the look you want, you can rate this film at ISO 800, 1600, 3200, or even 6400. This gives you tremendous control over the grain and contrast of the final images.

I also offer the prints in in a sepia-tone, if the bride so desires. In this case they are either printed on color paper, or the black & white images are toned.

In terms of lighting, I look for a nice directional quality. I try to position myself such that the main light source for the image is to my side. This way, the light streams across my subject, adding depth and dimension. If the light came from behind my back, the images would tend to look rather flat. In any case, if I have the chance to take a great action shot, I certainly won't let imperfect light stop me.

While evaluating the light in a scene, don't forget to take into account how your meter is "seeing" that light. Light meters are set to 18% grey. That means, when the light meter sees white, it thinks this is simply over-exposed 18% grey. It will stop down to compensate. (Conversely, when the light meter sees black, it will read it as under-exposed 18% grey and open up, trying to make it look 18% grey).

Obviously, this is an important factor to consider when shooting, for example, a full-frame image of a detail of the bridal gown. Unless you compensate, your image will be underexposed.

As a quick solution, I use the exposure lock button on my camera. I turn the camera to include non-white elements in the same light in the frame, lock in the balanced exposure, then turn and shoot the image.

Of course, the camera is only the beginning of creating storytelling images. It is a tool that must be used skillfully, but also backed up with attention to finding the right subjects and shooting them in appealing ways.

"... THE CAMERA IS ONLY THE BEGINNING OF CREATING STORYTELLING IMAGES."

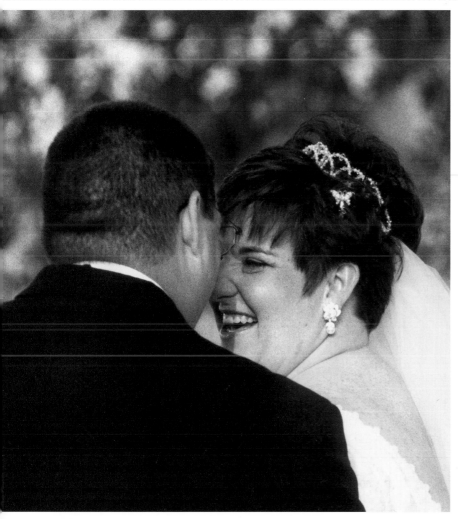

"**T**HERE ARE A FEW BASIC GUIDELINES THAT **I** TEND TO FOLLOW AS **I** AM SHOOTING..."

When my husband and I lecture on wedding photography, I am often asked, "How do you do it?" and "What are you thinking as you're shooting these images?" Others say, "Teach me how to take pictures like these!"

First, I am flattered that other photographers like my work (especially when photographers with much more experience than I have ask for my advice). In response to their questions, I reply that what I do, I do almost instinctively. There are, however, a few basic guidelines that I tend to follow as I am shooting storybook images at a wedding.

You have seen these in action throughout the previous sections, but they bear repeating. These guidelines are as follows:

1. I try to put myself in a "bride's state of mind." I remember the excitement and anticipation of my own wedding day. Perhaps because I work with my husband at weddings, I find it easy to get into a romantic mind-frame. Even if your significant other isn't with you, though, thinking about your loving feelings for him or her can help you get on the same wavelength as your subject.

2. As I arrive at the bride's home or at the church, I click my radar on and start

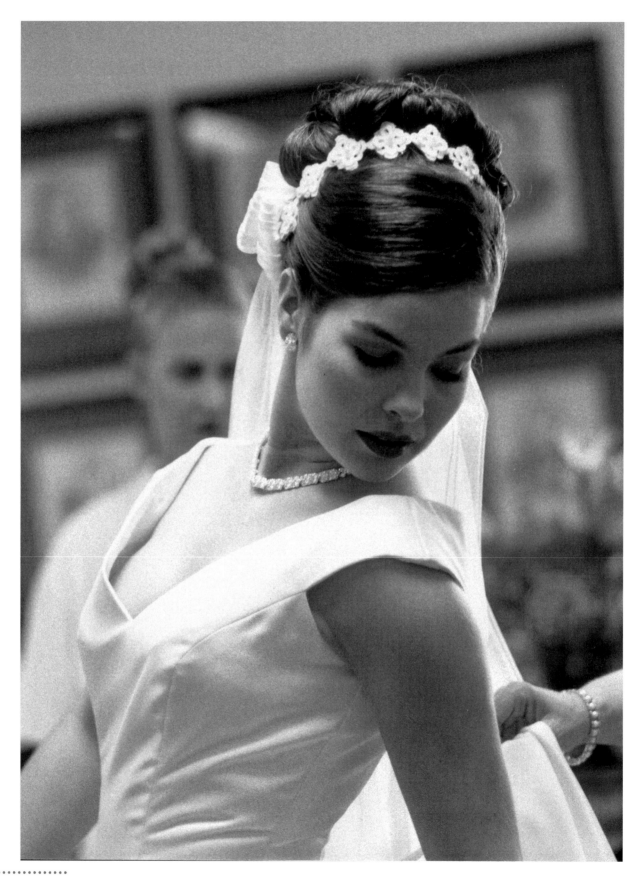

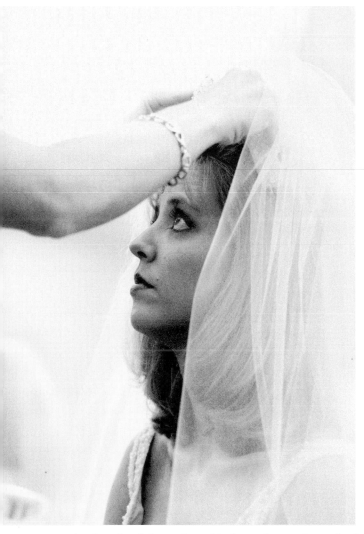
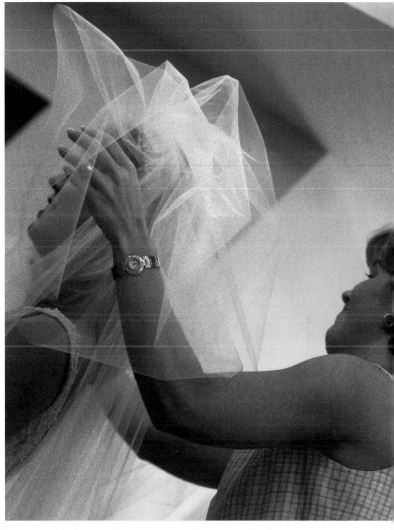

actively looking for little details and decorations that help give me insight into the bride's style and attitude. I observe and photograph these details carefully to build a full picture of the wedding day.

3. Once I've identified the details which help define the day, I look for unique ways to photograph them. I inspect every angle of the subject through the viewfinder. I try to find the representation which best tells the tale of this one little aspect of the big story. Finding the right composition is important to making the final photograph interesting for the viewer.

4. On an almost subconscious level I always have lighting in mind. Since I am shooting images of fleeting subjects, I do not have a lot of time to analyze and plan my lighting. Instead, I try to use a basic guideline which can be accomplished almost without thinking in any situation: whenever possible, I shoot with the main light source perpendicular to the camera and lens. This sidelighting provides consistently flattering results with beautiful texture. Of course,

"I TRY TO FIND THE REPRESENTATION WHICH BEST TELLS THE STORY..."

it's not always possible to achieve this, but it's a good place to start. Another look I enjoy is backlighting. If your subjects are standing close to a window, for instance, this can be a nice effect. I especially like backlight that comes from above the subject at a high angle.

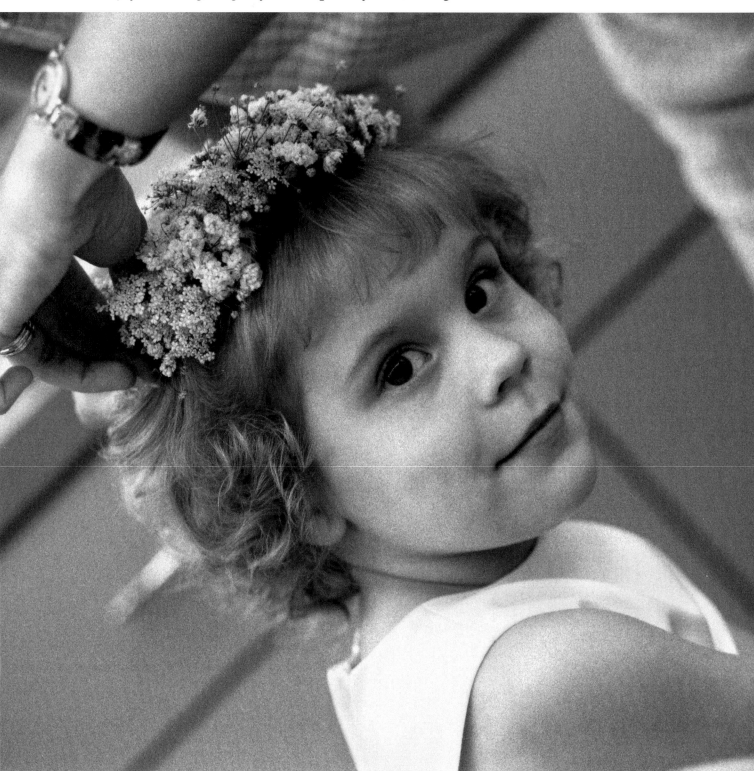

There are several basic categories of wedding photography. One of the oldest styles, and the most traditional, is the posed portrait. This type of image dates back well over one hundred years and has been used since photography was invented. Most older wedding photographs were taken in the studio where the bride and groom were posed together for a formal portrait.

As the years passed and photography became more advanced (and photography equipment more portable), the photographs changed. Images were taken on site at the wedding. Simple posed photographs were the standard, but might be combined with a few candid or action images. They were, of course, in black & white, and generally taken on 4"x5" sheet film.

"SIMPLE POSED PHOTOGRAPHS WERE THE STANDARD..."

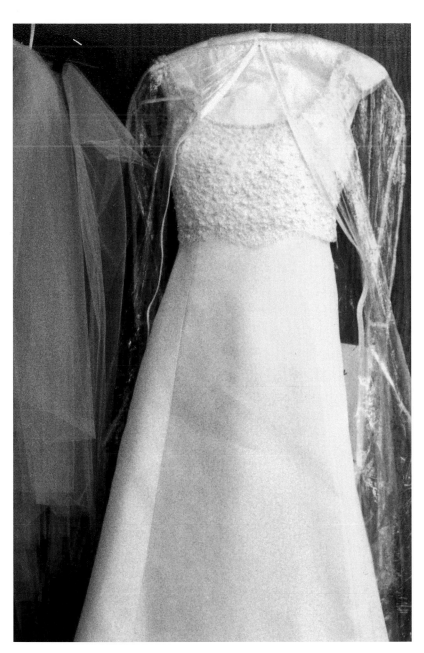

With the invention of roll films and smaller format cameras (medium format and 35mm format), photography was free to become even more spontaneous. The new equipment was much lighter and easier to hand-hold for spontaneous images, as well as much quicker to use. This allowed candids to be shot much more easily.

Still, most contemporary wedding photography is quite traditional, with the bulk of images in a bride's album being posed portraits of the bride and groom individually, the couple together and various groupings of the couple with the wedding party and their families.

While these images tend to be rather stiff and unnatural in appearance, they need not be. Instead of posing everyone precisely and instructing them to smile, some photographers (like my husband) are creating less formal posed images. Doug simply brings the subjects into a desired area, poses them loosely and lets the action take place. Some

"... THESE IMAGES TEND TO BE RATHER STIFF AND UNNATURAL IN APPEARANCE..."

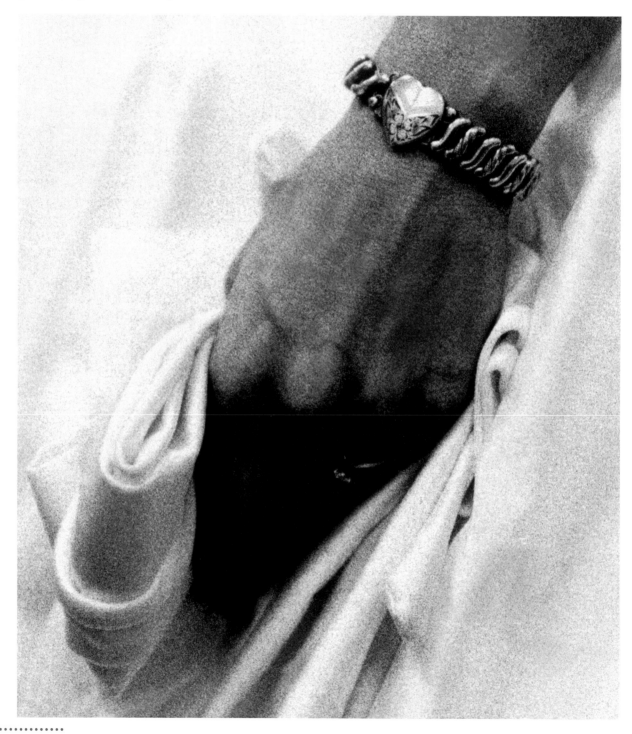

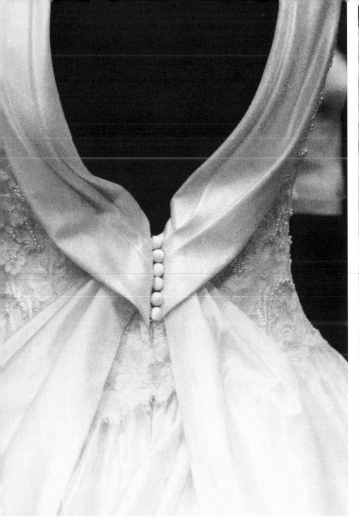
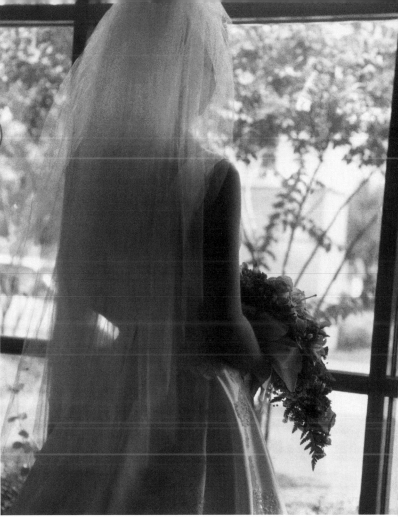

coaxing or direction may take place, but the majority of the action is natural.

The newest category of wedding photography is called "photojournalistic" and has affinities with candid photography, but adds a more storytelling style (hence its name). Some of these images stand alone, but many times a series of photographs is used to tell a story. This style of photography has become extremely popular, probably driven by the its wide use in magazines and advertising. The look is perceived as very fashionable and contemporary – very "real."

To me, the photojournalistic style is a welcome addition to the wedding photography repertoire. It results in images that are natural and spontaneous – and unique. Unlike stiff, posed portraits, the photojournalistic style allows the photographer to portray more of the unique character of the couple (instead of just what they looked like). It's a more "behind the scenes" look at the wedding.

"...THE PHOTOJOURNALISTIC STYLE ALLOWS YOU TO PORTRAY THE UNIQUE CHARACTER OF THE COUPLE..."

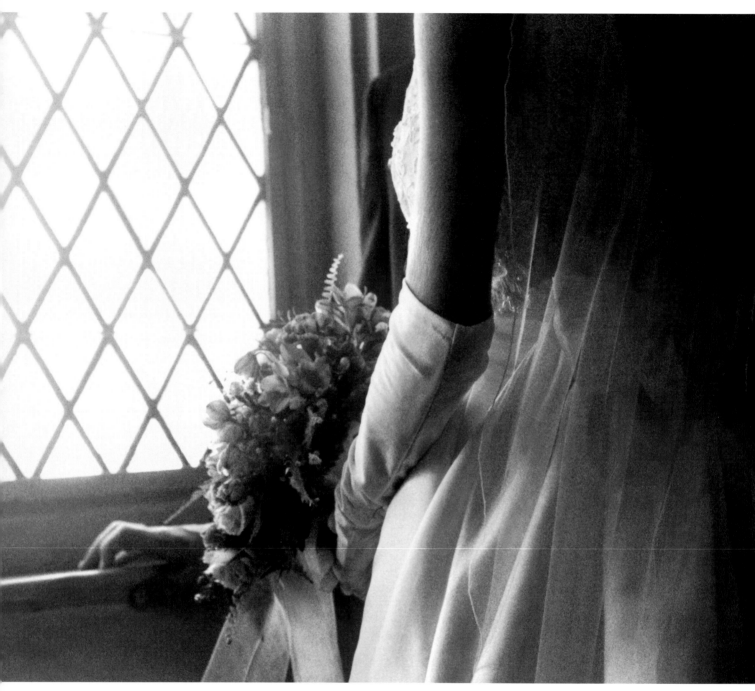

Still, photojournalism generally does not, to me, replace formal portrait photography. Instead, I think that all of these styles are important in wedding photography. No matter how great the storytelling portraits of the wedding are, the story is not complete without formal portraits. These images of the couple and their friends and family all looking their best, in carefully executed lighting are still high in demand and important to a comprehensive wedding album. To learn more about lighting an posing this type of image, consult *Professional Secrets of Wedding Photography*, by Douglas Box (Amherst Media, Inc.).

When I shoot a wedding I have something of a mental list of images to look for. The following list demonstrates the concept, but is certainly not exhaustive. Use it as a starting point and build on it to meet your own tastes and style. When you are stuck, a list can help you get started again.

If you combine items from two categories in one image, you can create great storytelling images. For example: grandparents' hands; the

As always, listening to the bride and her friends before the wedding is the best way to expand this outline and make sure it captures everything she finds important. Keep your eyes and ears open. Always be on the lookout for a unique part of the story and a creative way to depict it.

"...COMBINE ITEMS FROM TWO CATEGORIES IN ONE IMAGE..."

Things	Places	People	Emotions
dresses	church	grandparents	happiness
hands	in the limo	flowergirls	joy
details	reception	ring bearer	love
veil	bride's house	bride	nervousness
rings	dressing room	groom	hugs
flowers	powder room	parents	tears
limo	groom's room	bridesmaids	anticipation
cakes	outside	groomsmen	pride

dress in the dressing room; hugs at the reception, or love between the bride and groom.

Part of me is resistant to reducing storytelling to a list, of course. My fear is that because I list "grandparent's hand" that someone will instruct a grandmother to sit at a table and lay her hand out flat to be photographed. That's not storytelling any more than standing people in a straight line in front of a wall is portraiture.

The Wedding Album

My husband Doug and I work together to photograph weddings. He does color portrait photography (as well as candids in color), and I do black & white storytelling photography. The result is an album which combines both styles to tell the story of the day.

In the following pages I have included a sample from an album we did for a recent wedding. It demonstrates how we integrate the posed and un-posed images in the final book to create a narrative of the event.

As you will see, the two styles compliment each other nicely, resulting in a unique album that our brides love.

One of the services we offer our brides at no additional charge is album design. Instead of delivering the bride a bunch of loose photos or even a set of proofs in a book, we select the images and design the album. Our brides love this because it means we can deliver their final albums as little as four weeks after the wedding. We have found that more people see the bride's photographs in the first month she has them than at any other time. Having the images in a final, cropped and arranged format makes it more fun for her to look at the photos with her friends.

Some of the basic features of this system are:

1. Full storytelling of the wedding from start to finish in (generally) a 66 page Art Leather album.

2. Album features one of every great image we take, with no doubles of any image.

3. Mix black & white storytelling images with traditional color portraits and color candids.

4. Each two-page spread tells a story (no two events are on the same page).

5. Typical album includes: about thirty color enlargements (5x7, 8x8, 8x10, 10x10); one color panoramic print (8x20); about seventy color 4x5 and 5x5 prints, and 35-45 black & white prints.

5. Delivered complete to the bride in four to five weeks (after all, I know how anxious she'll be to see her photos).

The design of the album usually takes me about two full days. I study all of the photography and decide which images are the most interesting and beautiful. I try to create an album for each bride that is unique – different from any other bride's album. And they are! Even when we have shot many weddings at the same location, every album looks different. This custom product is an important part of the service we provide.

There are several benefits for the bride in taking advantage of a system like this. She has her final album in about a month (much less time than if we went through having her pick and arrange images from the proofs). The photographs are designed in a storytelling fashion. Her album will be a balanced and complimentary mix of color and black & white, narrating the full story. Finally, the bride knows exactly what she will be spending on photography. We sell her a complete package before the wedding, and

"THERE ARE SEVERAL BENEFITS FOR THE BRIDE IN TAKING ADVANTAGE OF A SYSTEM LIKE THIS."

collect the money then. This means there are no surprises for either of us (we know exactly what product we are shooting for, she knows exactly what she will be receiving).

There are also benefits for the photographer. When the bride shows the photographs to her friends and family for the first time, they will be in a finished format, not just a bunch of unorganized, uncropped proofs. Obviously, this puts your best foot forward and creates the best impression of your work. Designing the album yourself also saves you (and the bride) hours of time. You will avoid having to teach her about how to crop images or design an album. Most photographers give the bride the proofs and expect her to lay out the album herself. This is an inefficient system since the bride will not generally know the sizes in which photos can be printed, the cropping options available, the album page options, etc. The photographer, on the other hand, has had experience creating dozens of albums and has ready knowledge of all these topics. The photographer's experience can be applied to ensure that the final album looks its very best.

"THE PHOTOGRAPHER'S EXPERIENCE CAN BE APPLIED TO ENSURE THAT THE FINAL ALBUM LOOKS ITS VERY BEST."

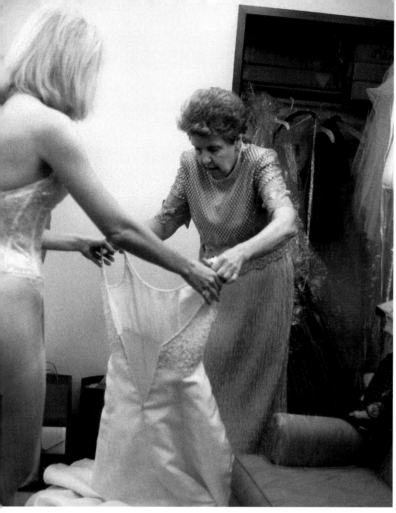

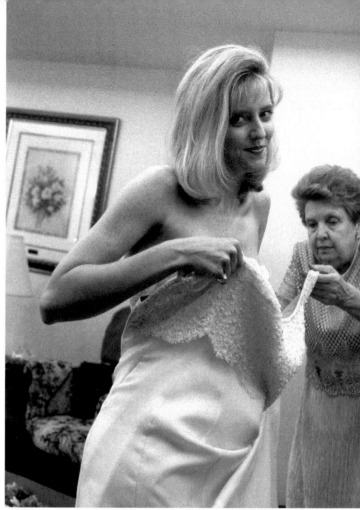

All the photos on this page were presented in black & white in the final album.

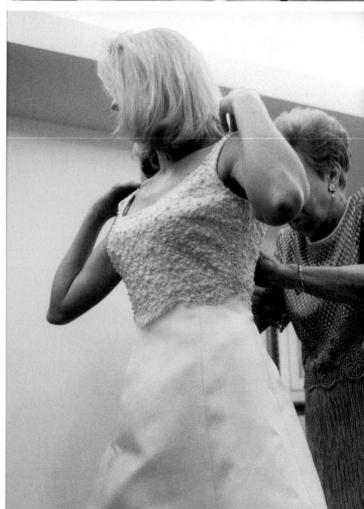

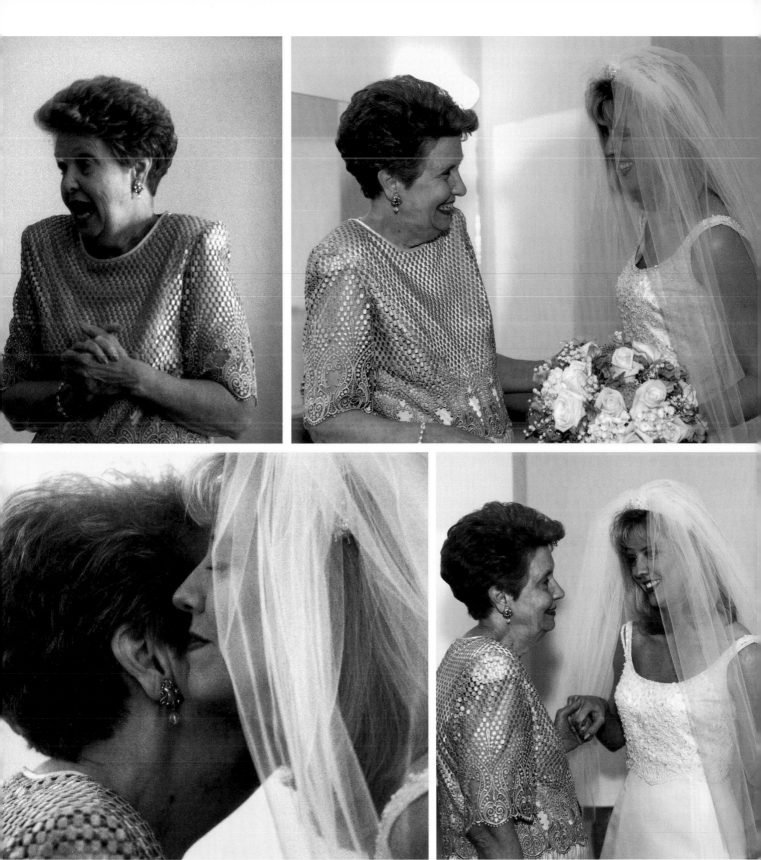

The two photos on the right were presented in color, and the two photos on the left were presented in black & white in the final album.

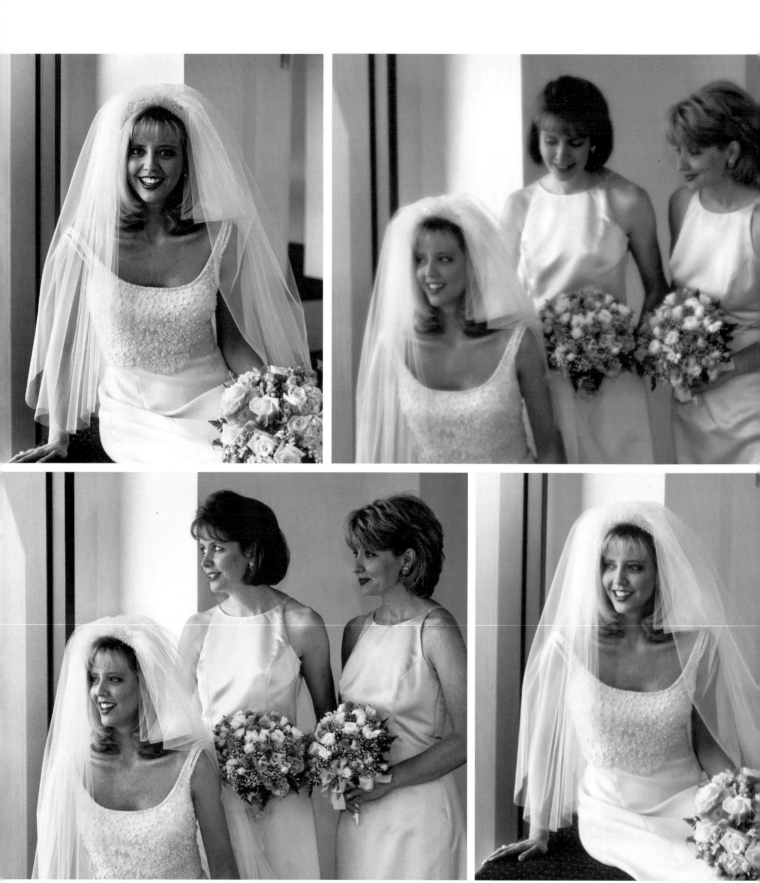

All of the photos on this page and the opposite page were presented in color in the final album.

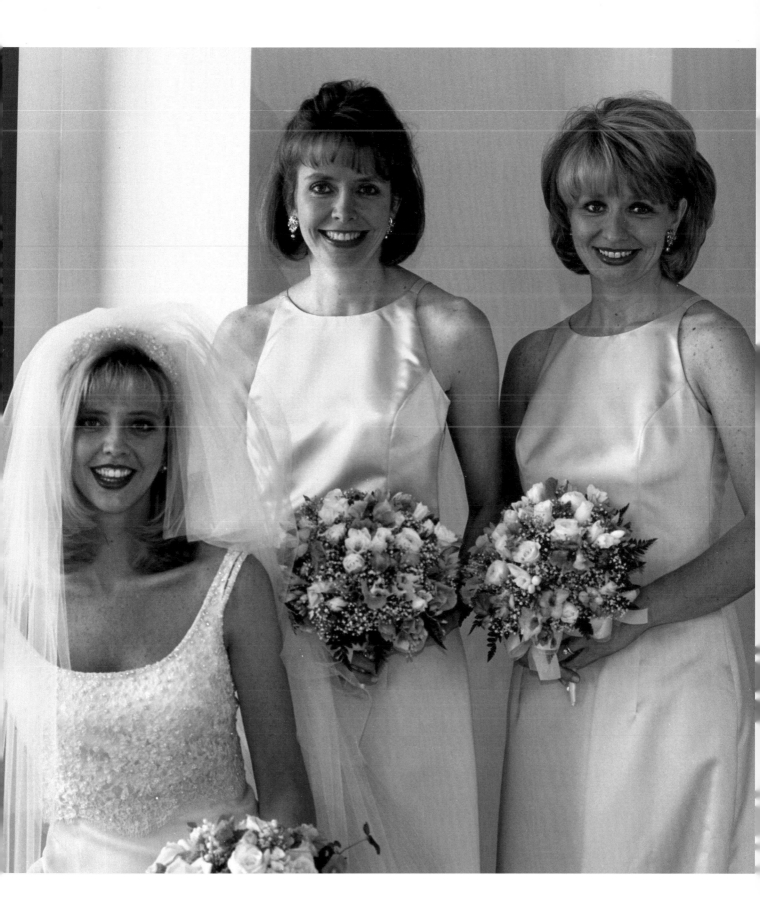

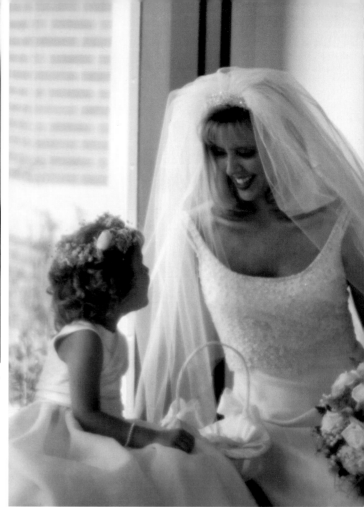

All the photos on this page and the opposite page were presented in color in the final album.

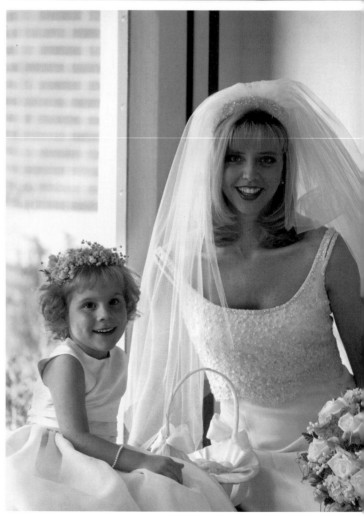

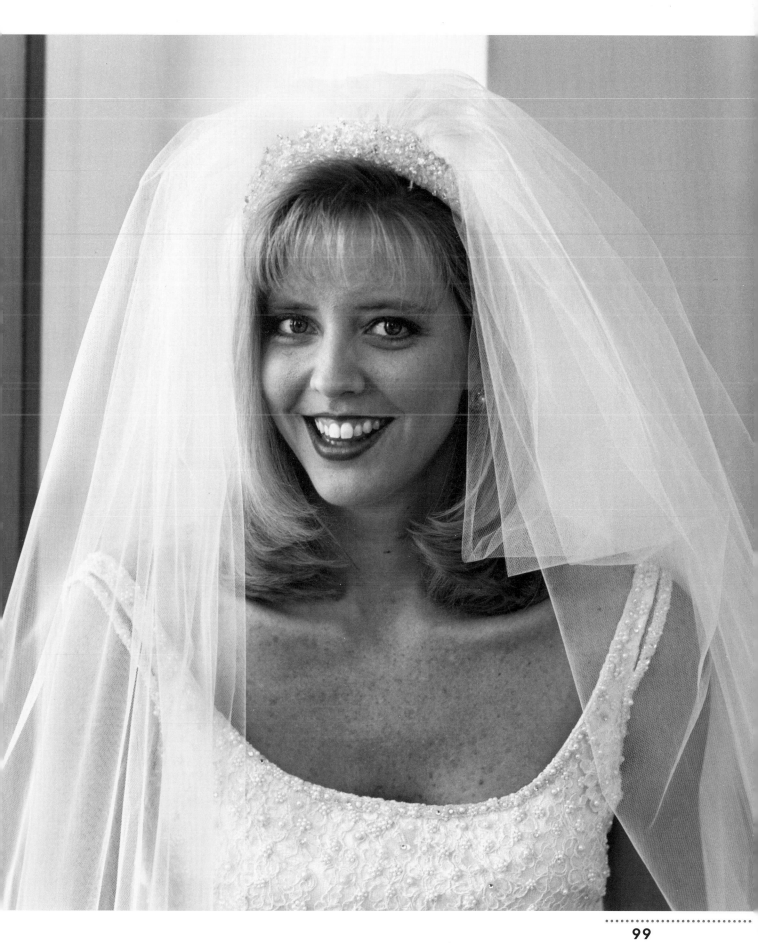

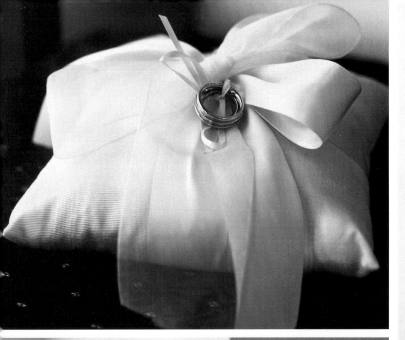

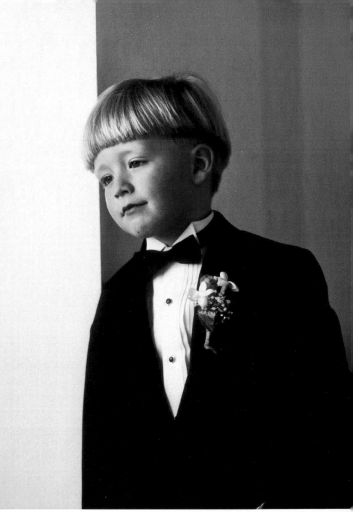

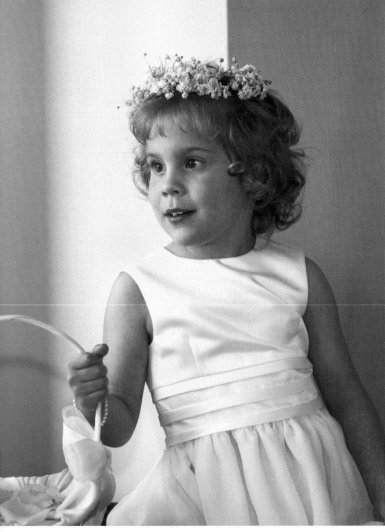

All the photos on this page and the opposite page were presented in color in the final album.

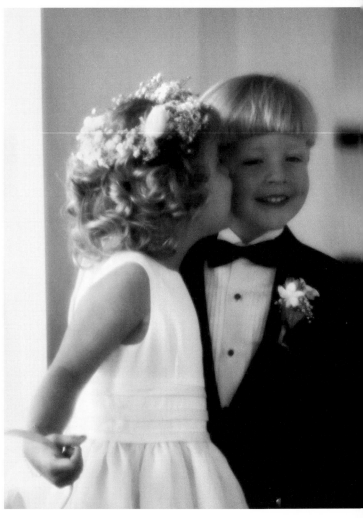

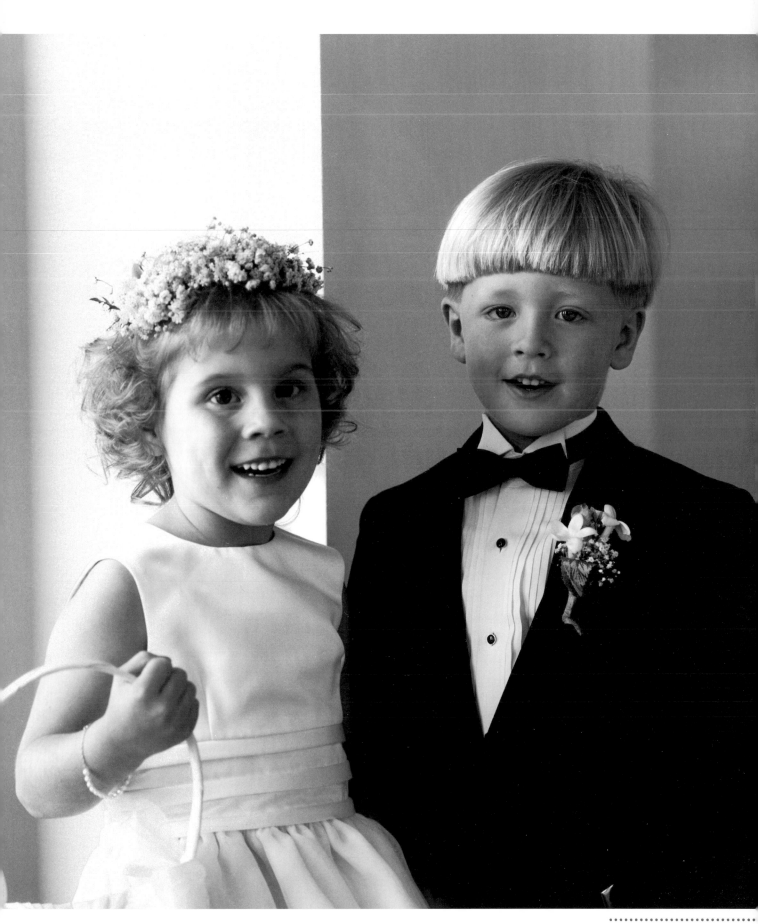

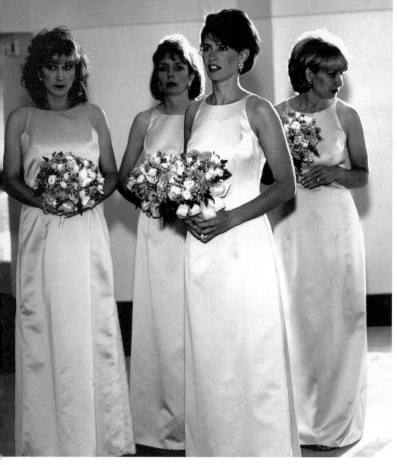

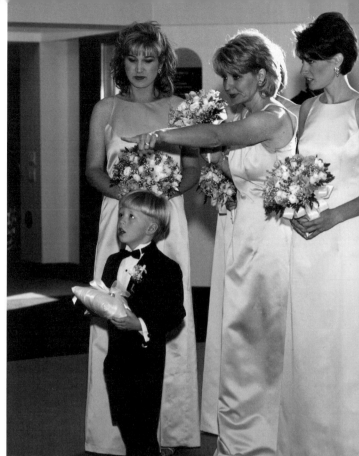

All the photos on this page were presented in color in the final album.

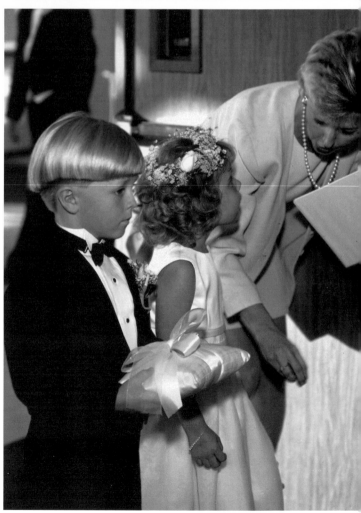

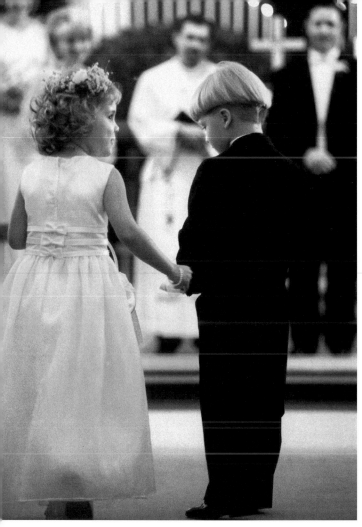

All the photos on this page were presented in black and white in the final album.

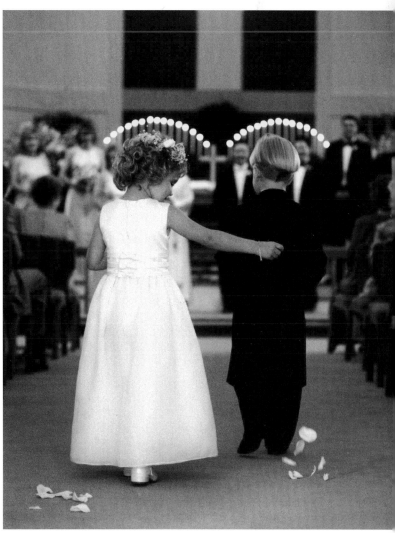

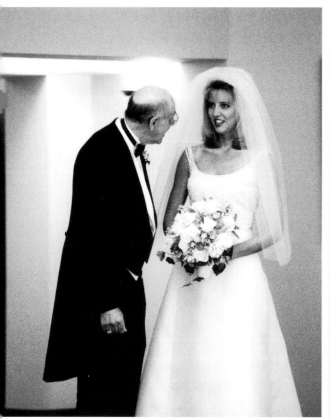

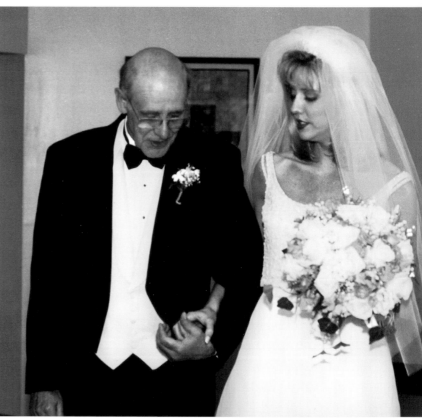

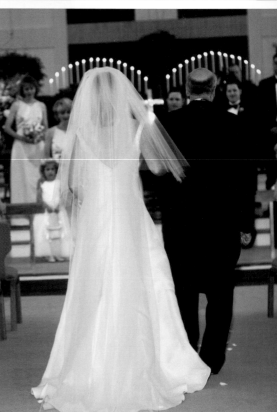

The two photos on the left were presented in black & white, and the two photos of the right were presented in color in the final album.

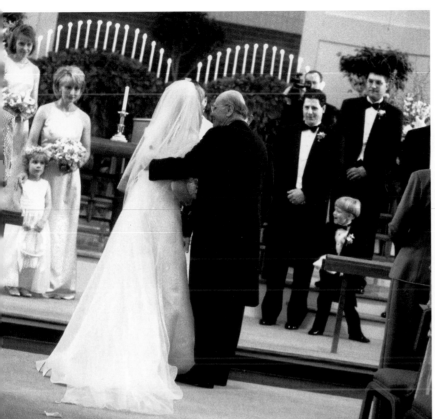

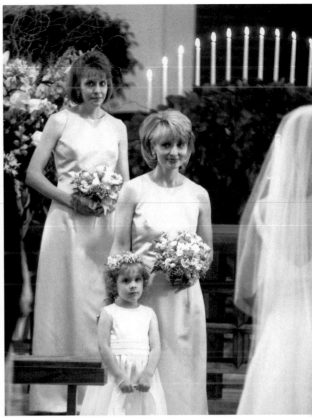

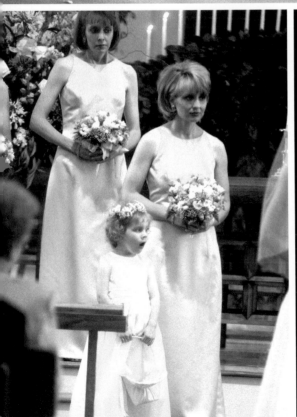

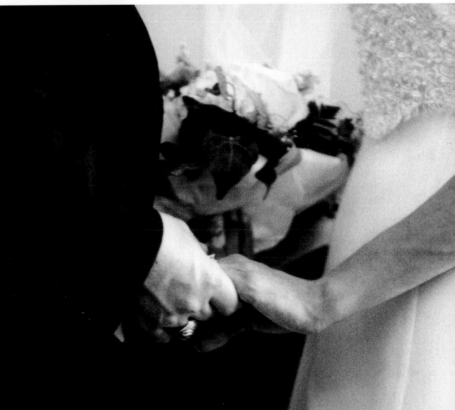

All of the photos on this page were presented in black & white in the final album.

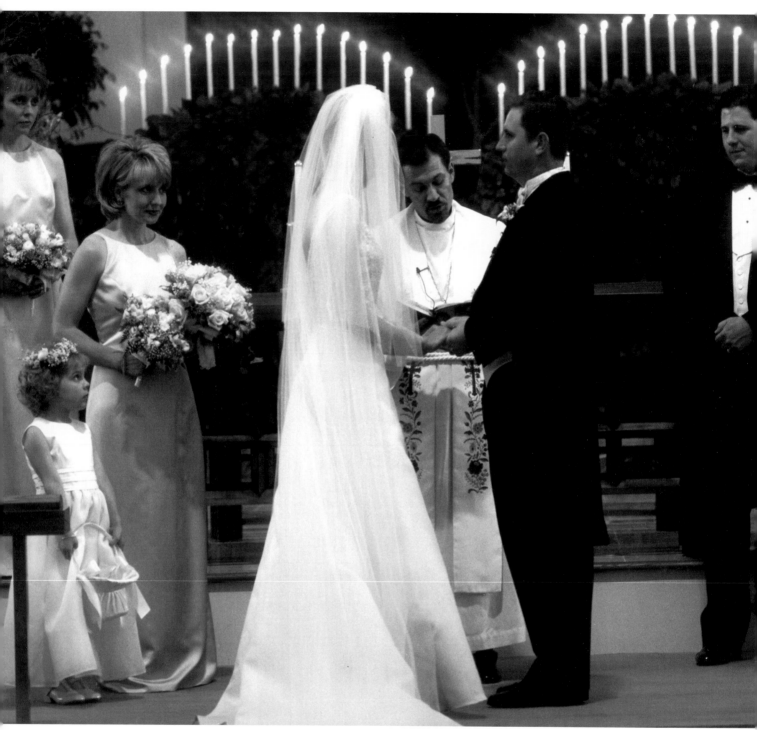

This image was presented in color in the final album.

LABS

• In-Focus
(black and white lab). 2503 Dunalvy,
Houston, TX. 77006. (713)529-5420.

• Ramsey Resources
(color lab and business consultant).
(800)844-5724

FILM

• Kodak TMZ 3200
(800)717-4040. < www.kodak.com > .

ALBUMS

• Art Leather
(888)AL-ALBUMS.
< www.artleather.com > .

• Albums, Inc.
(972)247-0677. < www.albumsinc.com > .

CAMERA

• Nikon 8008s
Nikon, 1300 Walt Whitman, Melville,
NY 11747. (800)NIKON-US.
< www.nikon.com > .

PROFESSIONAL ORGANIZATIONS

• Professional Photographers of America.
(800)786-6277. < www.ppa.com > .

• Wedding and Portrait Photographers
International
(310)451-0090.
< www.wppi–online.com > .

LECTURES AND SEMINARS

Doug and Barbara Box are also available
for lectures and seminars. They can be
contacted via their publisher at (800)633-
3278.

Index

Other Books from
Amherst Media, Inc.

Basic 35mm Photo Guide
Craig Alesse

Great for beginning photographers! Designed to teach 35mm basics step-by-step — completely illustrated. Features the latest cameras. Includes: 35mm automatic, semi-automatic cameras, camera handling, *f*-stops, shutter speeds, and more! $12.95 list, 9x8, 112p, 178 photos, order no. 1051.

Build Your Own Home Darkroom
Lista Duren & Will McDonald

This classic book teaches you how to build a high quality, inexpensive darkroom in your basement, spare room, or almost anywhere. Includes valuable information on: darkroom design, woodworking, tools, and more! $17.95 list, 8½x11, 160p, order no. 1092.

Into Your Darkroom Step-by-Step
Dennis P. Curtin

This is the ideal beginning darkroom guide. Easy to follow and fully illustrated each step of the way. Includes information on: the equipment you'll need, set-up, making proof sheets and much more! $17.95 list, 8½x11, 90p, hundreds of photos, order no. 1093.

Wedding Photographer's Handbook
Robert and Sheila Hurth

A complete step-by-step guide to succeeding in the world of wedding photography. Packed with shooting tips, equipment lists, must-get photo lists, business strategies, and much more! $24.95 list, 8½x11, 176p, index, b&w and color photos, diagrams, order no. 1485.

Lighting for People Photography
Stephen Crain

The complete guide to lighting. Includes: set-ups, equipment information, strobe and natural lighting, and much more! Features diagrams, illustrations, and exercises for practicing the techniques discussed in each chapter. $29.95 list, 8½x11, 112p, b&w and color photos, glossary, index, order no. 1296.

Camera Maintenance & Repair Book 1
Thomas Tomosy

A step-by-step, illustrated guide by a master camera repair technician. Includes: testing camera functions, general maintenance, basic tools needed and where to get them, basic repairs for accessories, camera electronics, plus "quick tips" for maintenance and more! $29.95 list, 8½x11, 176p, order no. 1158.

Camera Maintenance & Repair Book 2
Thomas Tomosy

Build on the basics covered Book 1, with advanced techniques. Includes: mechanical and electronic SLRs, zoom lenses, medium format cameras, and more. Features models not included in the Book 1. $29.95 list, 8½x11, 176p, 150+ photos, charts, tables, appendices, index, glossary, order no. 1558.

Outdoor and Location Portrait Photography
Jeff Smith

Learn how to work with natural light, select locations, and make clients look their best. Step-by-step discussions and helpful illustrations teach you the techniques you need to shoot outdoor portraits like a pro! $29.95 list, 8½x11, 128p, b&w and color photos, index, order no. 1632.

Make Money with Your Camera
David Arndt

Learn everything you need to know in order to make money in photography! David Arndt shows how to take highly marketable pictures, then promote, price and sell them. Includes all major fields of photography. $29.95 list, 8½x11, 120p, 100 b&w photos, index, order no. 1639.

Guide to International Photographic Competitions
Dr. Charles Benton

Remove the mystery from international competitions with all the information you need to select competitions, enter your work, and use your results for continued improvement and further success! $29.95 list, 8½x11, 120p, b&w photos, index, appendices, order no. 1642.

Freelance Photographer's Handbook

Cliff & Nancy Hollenbeck

Whether you want to be a freelance photographer or are looking for tips to improve your current freelance business, this volume is packed with ideas for creating and maintaining a successful freelance business. $29.95 list, 8½x11, 107p, 100 b&w and color photos, index, glossary, order no. 1633.

Wedding Photography:
Creative Techniques for Lighting and Posing

Rick Ferro

Creative techniques for lighting and posing wedding portraits that will set your work apart from the competition. Covers every phase of wedding photography. $29.95 list, 8½x11, 128p, b&w and color photos, index, order no. 1649.

Professional Secrets of Advertising Photography

Paul Markow

No-nonsense information for those interested in the business of advertising photography. Includes: how to catch the attention of art directors, make the best bid, and produce the high-quality images your clients demand. $29.95 list, 8½x11, 128p, 80 photos, index, order no. 1638.

Lighting Techniques for Photographers

Norm Kerr

This book teaches you to predict the effects of light in the final image. It covers the interplay of light qualities, as well as color compensation and manipulation of light and shadow. $29.95 list, 8½x11, 120p, 150+ color and b&w photos, index, order no. 1564.

Infrared Photography Handbook

Laurie White

Covers black and white infrared photography: focus, lenses, film loading, film speed rating, batch testing, paper stocks, and filters. Black & white photos illustrate how IR film reacts. $29.95 list, 8½x11, 104p, 50 b&w photos, charts & diagrams, order no. 1419.

How to Shoot and Sell Sports Photography

David Arndt

A step-by-step guide for amateur photographers, photojournalism students and journalists seeking to develop the skills and knowledge necessary for success in the demanding field of sports photography. $29.95 list, 8½x11, 120p, 111 photos, index, order no. 1631.

How to Operate a Successful Photo Portrait Studio

John Giolas

Combines photographic techniques with practical business information to create a complete guide book for anyone interested in developing a portrait photography business (or improving an existing business). $29.95 list, 8½x11, 120p, 120 photos, index, order no. 1579.

Fashion Model Photography

Billy Pegram

For the photographer interested in shooting commercial model assignments, or working with models to create portfolios. Includes techniques for dramatic composition, posing, selection of clothing, and more! $29.95 list, 8½x11, 120p, 58 photos, index, order no. 1640.

Computer Photography Handbook

Rob Sheppard

Learn to make the most of your photographs using computer technology! From creating images with digital cameras, to scanning prints and negatives, to manipulating images, you'll learn all the basics of digital imaging. $29.95 list, 8½x11, 128p, 150+ photos, index, order no. 1560.

Achieving the Ultimate Image

Ernst Wildi

Ernst Wildi teaches the techniques required to take world class, technically flawless photos. Features: exposure, metering, the Zone System, composition, evaluating an image, and more! $29.95 list, 8½x11, 128p, 120 b&w and color photos, index, order no. 1628.

Black & White Portrait Photography

Helen Boursier

Make money with b&w portrait photography. Learn from top b&w shooters! Studio and location techniques, with tips on preparing your subjects, selecting settings and wardrobe, lab techniques, and more! $29.95 list, 8½x11, 128p, 130+ photos, index, order no. 1626

The Beginner's Guide to Pinhole Photography

Jim Shull

Take pictures with a camera you make from stuff you have around the house. Develop and print the results at home! Pinhole photography is fun, inexpensive, educational and challenging. $17.95 list, 8½x11, 80p, 55 photos, charts & diagrams, order no. 1578.

Stock Photography
Ulrike Welsh

This book provides an inside look at the business of stock photography. Explore photographic techniques and business methods that will lead to success shooting stock photos — creating both excellent images and business opportunities. $29.95 list, 8½x11, 120p, 58 photos, index, order no. 1634.

Profitable Portrait Photography
Roger Berg

A step-by-step guide to making money in portrait photography. Combines information on portrait photography with detailed business plans to form a comprehensive manual for starting or improving your business. $29.95 list, 8 1/2x11, 104p, 100 photos, index, order no. 1570

Professional Secrets for Photographing Children
Douglas Allen Box

Covers every aspect of photographing children on location and in the studio. Prepare children and parents for the shoot, select the right clothes capture a child's personality, and shoot story book themes. $29.95 list, 8½x11, 128p, 74 photos, index, order no. 1635.

Telephoto Lens Photography
Rob Sheppard

A complete guide for telephoto lenses. Shows you how to take great wildlife photos, portraits, sports and action shots, travel pics, and much more! Features over 100 photographic examples. $17.95 list, 8½x11, 112p, b&w and color photos, index, glossary, appendices, order no. 1606.

Handcoloring Photographs Step-by-Step
Sandra Laird & Carey Chambers

Learn to handcolor photographs step-by-step with the new standard in handcoloring reference books. Covers a variety of coloring media and techniques with plenty of colorful photographic examples. $29.95 list, 8½x11, 112p, 100+ color and b&w photos, order no. 1543.

Special Effects Photography Handbook
Elinor Stecker Orel

Create magic on film with special effects! Little or no additional equipment required, use things you probably have around the house. Step-by-step instructions guide you through each effect. $29.95 list, 8½x11, 112p, 80+ color and b&w photos, index, glossary, order no. 1614.

Fine Art Portrait Photography
Oscar Lozoya

The author examines a selection of his best photographs, and provides detailed technical information about how he created each. Lighting diagrams accompany each photograph. $29.95 list, 8½x11, 128p, 58 photos, index, order no. 1630.

Family Portrait Photography
Helen Boursier

Learn from professionals how to operate a successful portrait studio. Includes: marketing family portraits, advertising, working with clients, posing, lighting, and selection of equipment. Includes images from a variety of top portrait shooters. $29.95 list, 8½x11, 120p, 123 photos, index, order no. 1629.

The Art of Infrared Photography, *4th Edition*
Joe Paduano

A practical guide to the art of infrared photography. Tells what to expect and how to control results. Includes: anticipating effects, color infrared, digital infrared, using filters, focusing, developing, printing, handcoloring, toning, and more! $29.95 list, 8½x11, 112p, order no. 1052

The Art of Portrait Photography
Michael Grecco

Michael Grecco reveals the secrets behind his dramatic portraits which have appeared in magazines such as *Rolling Stone* and *Entertainment Weekly*. Includes: lighting, posing, creative development, and more! $29.95 list, 8½x11, 128p, order no. 1651.

Essential Skills for Nature Photography
Cub Kahn

Learn all the skills you need to capture landscapes, animals, flowers and the entire natural world on film. Includes: selecting equipment, choosing locations, evaluating compositions, filters, and much more! $29.95 list, 8½x11, 128p, order no. 1652.

Photographer's Guide to Polaroid Transfer
Christopher Grey

Step-by-step instructions make it easy to master Polaroid transfer and emulsion lift-off techniques and add new dimensions to your photographic imaging. Fully illustrated every step of the way to ensure good results the very first time! $29.95 list, 8½x11, 128p, order no. 1653.

Black & White Landscape Photography

John Collett and David Collett

Master the art of b&w landscape photography. Includes: selecting equipment (cameras, lenses, filters, etc.) for landscape photography, shooting in the field, using the Zone System, and printing your images for professional results. $29.95 list, 8½x11, 128p, order no. 1654.

Wedding Photojournalism

Andy Marcus

Learn the art of creating dramatic unposed wedding portraits. Working through the wedding from start to finish you'll learn where to be, what to look for and how to capture it on film. A hot technique for contemporary wedding albums! $29.95 list, 8½x11, 128p, order no. 1656.

Studio Portrait Photography of Children and Babies

Marilyn Sholin

Learn to work with the youngest portrait clients to create images that will be treasured for years to come. Includes tips for working with kids at every developmental stage, from infant to pre-schooler. Features: lighting, posing and much more! $29.95 list, 8½x11, 128p, order no. 1657.

Professional Secrets of Wedding Photography

Douglas Allen Box

Over fifty top-quality portraits are individually analyzed to teach you the art of professional wedding portraiture. Lighting diagrams, posing information and technical specs are included for every image. $29.95 list, 8½x11, 128p, order no. 1658.

Photographer's Guide to Shooting Model & Actor Portfolios

CJ Elfont, Edna Elfont and Alan Lowry

Learn to create outstanding images for actors and models looking for work in fashion, theater, television, or the big screen. Includes the business, photographic and professional information you need to succeed! $29.95 list, 8½x11, 128p, order no. 1659.

Photo Retouching with Adobe Photoshop

Gwen Lute

Designed for photographers, this manual teaches every phase of the process, from scanning to final output. Learn to restore damaged photos, correct imperfections, create realistic composite images and correct for dazzling color. $29.95 list, 8½x11, 128p, order no. 1660.

Creative Lighting Techniques for Studio Photographers

Dave Montizambert

Master studio lighting and gain complete creative control over your images. Whether you are shooting portraits, cars, table-top or any other subject, Dave Montizambert teaches you the skills you need to confidently create with light. $29.95 list, 8½x11, 128p, order no. 1666.

Fine Art Children's Photography

Doris Carol Doyle

Learn to create fine art portraits of children in black & white. Included is information on: posing, lighting for studio portraits, shooting on location, clothing selection, working with kids and parents, and much more! $29.95 list, 8½x11, 128p, order no. 1668.

Infrared Portrait Photography

Richard Beitzel

Discover the unique beauty of infrared portraits, and learn to create them yourself. Included is information on: shooting with infrared, selecting subjects and settings, filtration, lighting, and much more! $29.95 list, 8½x11, 128p, order no. 1669.